OSO: Este libro te lo regalo
Yo para que te distraigas
y sientas mejor.

Te Quiero Mucho!
Ernesto
10-99

IMPRESSIONISM

BARRON'S ART HANDBOOKS

IMPRESSIONISM

BARRON'S

CONTENTS

INTRODUCTION

Our purpose in publishing this handbook was to provide readers with an encyclopedic view of one of the most unique and important periods in modern art. We have done this to the extent possible given the size and scope of the topic.

The Impressionists' break from the classical tradition taught by the academies and fine arts schools, and from official canons of art, and their adoption of a position diametrically opposed to all that had come to define concepts of light, color, composition, pose, setting, and general treatment of subject matter represented a true revolution. Their approach to art also marked an extremely important milestone in the history of art in general and painting in particular. Painting nature in the open air, representing subjects engaged in everyday activities (peasants working in fields, street scenes, people going about their daily lives, etc.) and depicting unusual settings (cafés, dance halls, brothels, and so on) were innovations that were considered scandalous by the conservative and orthodox members of the art establishment but that were met with enthusiasm by the younger generation. Whether one agrees or disagrees with the ideas of Impressionist artists, and likes or dislikes the way they interpret and represent art, it is clear that the Impressionists, like few other artists, considered art as essential and fought hard to disseminate their ideas.

This brief commentary conveys the importance of the pictorial movement to which this book is dedicated.

A problem common to books like this one is how to delineate the boundaries that distinguish one art movement from another. Ideas and styles evolve and consolidate slowly during each stage, in a process characterized by highs and lows, hesitations, steps forward and, at times, steps backward, until they crystallize. Artists also go through different phases or periods throughout their lifetime, making it sometimes impossible to ascribe them to a singular school. While many of the artists in this book were not Impressionists all of their lives, they have been included here because the works they produced during the peak of the Impressionist period were decisive in helping to shape and define the movement.

We focus here mainly on French painters, as they gave birth to Impressionism and inspired followers in other countries. However, we have also included in our study non-French painters, such as V.W. van Gogh, J.M.W. Turner, J. Constable, and M. Cassat, because of their valuable contributions to the movement. The last chapter of the book presents a brief description of the influence of Impressionism on well-known artists from other countries.

In addition to presenting a narrative on the history of Impressionism, this handbook is also intended to be a source of visual and factual information. It is our hope that this brief, concise manual, containing dates, facts, names, works, distinctive features, and milestones, will be of enormous help and interest to readers.

Jordi Vigué

PRECURSORS: INFLUENCES AND CHARACTERISTICS

The French Academy severely restricted an artist's choice of style and subject matter, which constrained many innovative painters. These artists reacted by seeking inspiration in the works of painters who used a freer brushstroke and had a unique understanding of the effects of light in figure and landscape painting.

The Period of Transition. The Nineteenth Century

French classicism set the standards for official art. From the time of the French Revolution in 1789 painting had been one of the main vehicles for exalting national and historical events. American artists, such as Copley (1737–1815), were influential in generating interest in realistic, historical, and political topics, and in introducing a theatrical element in painting.

The French Academy. Ingres and David

Ingres and David are the two leading representatives of the French Academy:

Jacques-Louis David (1748–1825), official artist of the Revolutionary Government, introduced, within the classical tradition, several important changes to the style of his predecessors:

• A classical approach to painting without the use of excessive color shading and complex foreshortening of shapes.

Self-portrait of J.A.D. Ingres.

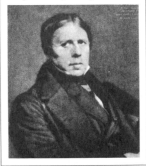

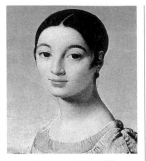

J.A.D. Ingres (1780–1867), Portrait of Mlle. Riviere, oil. The Louvre, Paris.

• Sharp modeling of figures.

Jean-Auguste-Dominique Ingres (1780–1867), student of David, preserver and admirer of heroic art. The perfect composition and execution of his works led artists, such as Delacroix, to abandon their search for perfection in the imitation of classical sculptures.

Velázquez and Turner, Pioneers of Their Time

Impressionism drew from many different sources, which resulted in an aesthetic way of conceptualizing different aspects of painting, mostly as a reaction to traditional, classical art. This is clear in the work of several artists who pioneered the idea of freedom in painting, such as:

Diego Velázquez (Seville, 1599–1660) was one of the painters who most influenced the Impressionists.

Formal Influences:

• Framed a subject as a window on reality.

• Used popular subjects rather than those prescribed by classical art (dwarfs, courtesans, etc.).

Technical Influences:

• Rendered shapes in patchwork style, heralding the Impressionist theory of color.

J.L. David (1748–1825), The Consecration of Napoleon (fragment), oil. The Louvre, Paris.

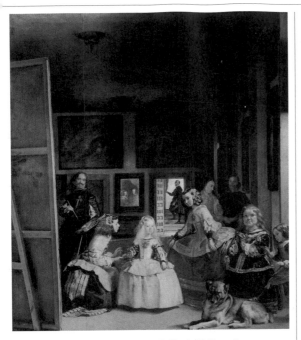

D. Velázquez (1599–1660), The Young Ladies in Waiting, *oil on canvas.*
Prado Museum, Madrid.

Technical Influences:
• Painted from first impressions, quick execution.
• Abandoned academic themes in painting.

The First Pictorial Revolution: Delacroix

Eugène Delacroix (1798–1863) was Ingres' chief rival. He promoted a break with academic technique.
Formal Influences:
• Abandoned cultural and antiquity themes.
• Foreshadowed realism in painting.
• Included ordinary people in his paintings.
Technical Influences:
• No longer used modeling in figure painting.
• Abandoned precise outlining of forms.

• Used pure colors.
• Painted directly on the canvas, usually completing a painting in a few sessions.
Joseph Mallord William Turner (1775–1851), ahead of his time, contributed a number of ideas that were later adopted by the Impressionists.

Formal Influences:
• Had a pictorial interest in the phenomenology of light.
• Portrayed in an abstract fashion the different components within landscape painting.
• Was an early user of watercolor as a pictorial medium.
• Created a school that linked his work to Impressionism.

E. Delacroix (1798–1863),
Liberty Leading the People
(detail). *The Louvre, Paris.*

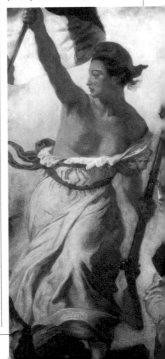

J.M.W. Turner (1775–1851), Cottage Destroyed by an Avalanche of Light and Color, *oil. Tate Gallery, London.*

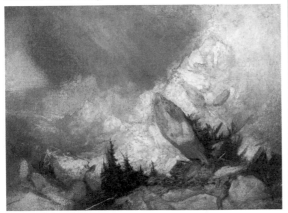

FROM CLASSICISM TO REALISM

As a reaction to the tradition of the French Academy, a series of painters made changes that affected not only style and technique but also the way of looking at art.

The Second Revolution in Painting

If the aim of the first revolution in art was to arrest the development of techniques upheld by classical artists, the aim of the aesthetic debate in pursuit of realism was to do away with the thematic scheme of historical events.

Rousseau and the Barbizon School

Landscape painting in England, practiced by such artists as Constable and Bonington, enjoyed a greater freedom of form than in France and developed artistic expressions that

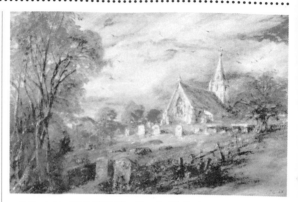

J. Constable (1776–1837), The Church of Stoke Poges, *oil on canvas. Victoria and Albert Museum, London.*

were very different from those of classicism. Following in Constable's footsteps, Théodore

Rousseau and several of his disciples founded the Barbizon School in the second half of the 1840s.

Millet moved to Barbizon in 1849 and further developed Rousseau's principles in his landscapes depicting peasants at work, which were devoid of romantic elements.

Formal and Technical Contributions of the Barbizon School

• Painting from nature (only notes and sketches were needed, since the painting was completed in the studio).
• Total disregard for the dramatic in painting.
• Appreciation of ordinary people, such as peasants and workers, as a thematic scheme of pictorial interest.

Barbizon Influences on the Impressionists

• Painting done entirely outdoors.
• Search for a landscape's true colors based on actual light

A.L.R. Ducros, Night Storm in Cefalou, Calabria. *Cantonal Museum of Fine Arts, Lausanne. An example of Romantic painting.*

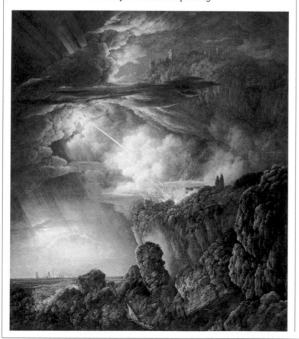

conditions. Traditionally, paintings were done in the studio and were based on the artist's recollection of the colors.
• Break with the thematic subjects painted in traditional Romantic landscapes.

Nature in the Open Air

Beginning with the Barbizon School, a need and interest grew among avant-garde painters to capture nature in its purest state, directly from life. The works they produced were in direct conflict with the mannered aesthetics of official paintings, which were always done in the painter's studio, entirely from memory and lacking lifelike colors.

Realism and Courbet

The Barbizon School made it very clear to viewers that truth, not beauty, should be sought in paintings. This resolve led Gustave Courbet (Ornans 1819–1877) to organize an exhibition in Paris called *Realism, G. Courbet.*

The Goals of Realism

• Protest against bourgeois conventionality in painting.
• Artistic truthfulness.
• Renunciation of styles found in official painting.

Conservative Protest

Courbet's exhibition met with acerbic criticism from art experts, which served to further encourage the Realist movement.
• The critics attacked *Burial at Ornans* as crude and ugly.

• Courbet's naturalism irritated the bourgeois public.
• Critics called Courbet a *revolutionary* and a *socialist,* both for his choice of subject matter and his disdain toward the art establishment.

T. Rousseau (1812–1867), View of Fontainebleau *(fragment), sketch, India ink and tempera, 7.5 × 10 in. The Louvre, Cabinet des Dessins, Paris.*

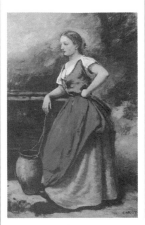

C. Corot (1796–1875), Young Woman at the Well, *oil. Köller-Müller Museum, Otterlo. The Barbizon School brought an end to Romanticism.*

Photograph of the building of Durand-Ruel's gallery, where G. Courbet, in 1845, organized the exhibition Realism.

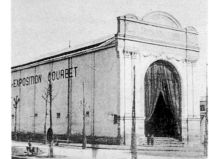

G. Courbet (1819–1877), The Burial of Ornans *(detail), oil on canvas. The Louvre, Paris.*

LE SALON DES REFUSÉS
(THE SALON OF THE REJECTED WORKS)

In 1863 the jury refused to accept the works of several artists for the Academy's annual Salon exhibition because of their unconventional themes and techniques. The rejected painters gathered and showed their works in an exhibition that was called le Salon des Refusés, (a formally recognized exhibition of the rejected works). The public and the critics attended the exhibition only to ridicule the works of these artists. The greatest scandal was caused by Édouard Manet with his two works *Luncheon on the Grass* and *Olympia*. The characteristic features of these works form the cornerstone of the third pictorial revolution in France.

New Challenge for Art

Édouard Manet (1832–1883) launched the third pictorial revolution, after those by Delacroix and Courbet. Manet's work exhibited at le Salon des Refusés displayed several features that became important in the development of Impressionism.

Thematic Differences

Manet—A nude figure did not need to maintain a spatial and temporal distance from the viewer.

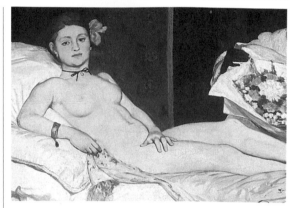

É. Manet (1832–1883), Olympia *(fragment), oil on canvas. The Louvre, Paris.*

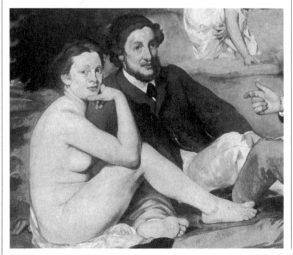

É.Manet (1832–1883), Luncheon on the Grass *(fragment), oil on canvas. The Louvre, Paris. Contrary to academic painting, Manet's nude does not maintain a distance from the spectator, but instead provokes and challenges the viewer with her gesture and look. The modernity of the painting was born unintentionally.*

Official painting—Nude figures were to be based on models represented in classical or mythological themes.

Manet—The pose of the nude engages viewers, defying them with her gaze.

Official painting—The pose does not engage the viewer, but remains distant and detached.

Technical Differences

Manet—The light shining on the figure is presented in a realistic manner, avoiding tonal emphasis when necessary. Shadows are affected by the colors that surround them.

Official painting—Tonal emphasis shapes forms with masses devoid of reality, depicting careful modeling even when the light is direct, as if one were dealing with a study in plaster.

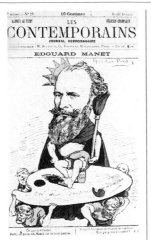

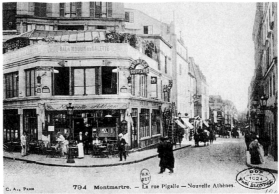

Postcard of the period showing the Café La Nouvelle Athènes in Place Pigalle. Meetings in the cafés were crucial for debating the theory of the new aesthetic and plastic trends.

Caricature of the period satirizing Édouard Manet as the king of the new movement.

The Critics

Critics and conservative painters were merciless in their review of the 1863 exhibition, denouncing both technical and thematic aspects of the works exhibited. However, the criticism that so beleaguered the new pictorial revolution was also the best propaganda for spreading the new theories.

The New Theories

• Search for real colors viewed in the light.
• Need to paint outdoors.
• Disdain for traditional color harmonies.
• Shaping objects through tonal gradations is replaced by the use of sharp contrasts.
• Search for unusual themes that today would be considered ordinary: train stations, dance halls, bar scenes, parties, everyday activities.
• Interest in capturing movement and speed.

The Group and Their Gatherings

Manet unwillingly became the leader of a group of young artists that included, among others, Monet, Renoir, Bazille, Morisot, Sisley, and Cézanne. The group held social gatherings at the Café Guerbois in Batignolles and in their own studios, and discussed the new theories in depth.

The new theories received the support of several intellectuals of their time, such as Baudelaire and Zola.

Manet and the Impressionists

Manet tried to keep his distance from the Impressionist group and did not take part in their exhibitions; however, he met with them and particularly enjoyed the company of Degas. His sister-in-law, the painter Berthe Morisot, modeled for him on several occasions and encouraged him to paint outdoors.

Manet was in constant contact with the group, despite the fact that his main interest lay in having his paintings accepted by the official art world. Contact among the painters was important for the development of the different aesthetic positions. Often, the painters were united more by friendship than by artistic style.

É. Manet (1832–1883), Meeting at the Café Guerbois. *Ink drawing.*

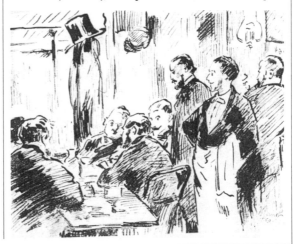

THE NEW CONCEPT: IMPRESSIONISM

Among the group of like-minded painters surrounding Manet, a young artist stood out who, although of humble origins, exhibited a high sense of purpose: Claude Monet (1840–1926). Monet was the first painter in the group to radically change his approach by painting from real life in the open air.

Monet, *Impression: Sunrise*

While Manet's work was, for the most part, widely accepted by the critics and the public, the painters in Monet's group still experienced enormous difficulty in getting their works accepted by the Salon.

The title of this work by Monet gave its name to the group, which was derisively christened by the critics as *Impressionists*.

Following is the basic chronology of the evolution of Impressionism:

1874—First exhibition in the studio of photographer Nadar, with works by Monet, Cézanne, Degas, Pissarro, Renoir, and Sisley. One of Monet's paintings was called *Impression: Sunrise*. The Parisian critic Louis Leroy sarcastically called the group *Impressionists*.

1876—Exhibition at the home of Durand-Ruel, the Impressionist group's first art dealer, with negative press reviews.

Nadar's studios, site of the first Impressionist exhibition, held in 1874.

Cover of L'Impressionniste, *with a drawing by Sisley. This short-lived publication contained discussions on Impressionist theories and complaints about official art.*

1886—Highly successful Impressionist exhibition in New York organized by Durand-Ruel.

1886—Dissolution of the Impressionist group. Luncheons at the Café Riche gave rise to Neo-Impressionist theories. These social gatherings were extremely important because they gave artists an opportunity to debate their different theories.

Monet's Contributions to the Impressionist Movement

• Nature undergoes perpetual

Daumier, Nadar Elevating Photography to the Status of Art.

change; painting should be done outdoors to capture reality.

• Painting should be started and finished on location.

• Painters should conform to nature, foregoing their own personal preference.

• Color should be directly applied to the canvas, not to a darkened background.

• The effect of the painting should be focused on its overall impression, rather than on the details.

Themes

• The Impressionist landscape disregards the picturesque and focuses on capturing the moment and the light shining on

Photograph of a moving train taken by Zola. The train was one of the recurring themes in the work of several Impressionists.

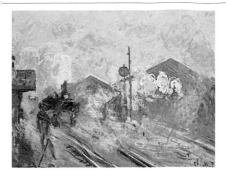 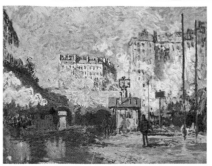

Two versions of the Saint-Lazare station by Monet, oil on canvas. The first dates from 1877, the second from 1878.

objects.

• Special importance is given to urban landscapes as a testing ground for light: reflection of adjacent colors and atmospheric effects such as smoke, haze, etc.

• The haziness of objects is an incentive and a challenge for the Impressionist painter: crowds of people, an urban landscape viewed through a grove, and so on.

• The Impressionist painter deals with all of the events of everyday life: parties, dances, etc. Renoir specialized in these themes.

Photography and Painting

The first portable photographic camera appeared at about the same time as the first Impressionist exhibition. This new tool served, on many occasions, as a source of inspiration for painters, who could take instant pictures and freeze movement, composition, and scenes on a plate.

The photograph, which represented a serious competitive challenge to academic painting, became an important tool for Impressionist painters.

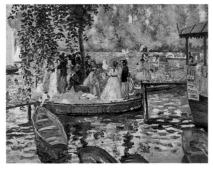

Artists often painted the same scene side by side, as in this example by Renoir (illustration above: La Grenouillère, *oil. Musée d'Orsay, Paris) and Monet (illustration below:* La Grenouillère, *oil. Musée d'Orsay, Paris).*

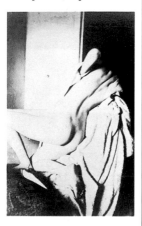

Degas (1834–1917), After the Bath. *Impressionist painters, investigators of light and movement, often used photographs as the basis for their work.*

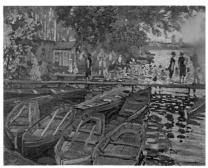 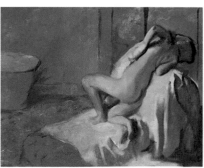

CHANGES IN THE CONCEPTION OF PAINTING

As a new pictorial revolution was evolving, new technical innovations caught the public's eye. Photography quickly encroached upon the art world and provided artists with a means to gain different perspectives, themes, graphic documentation, and a new appreciation for configurations seen as large masses of grays. Japanese prints also captured the interest of painters, who were tired of the Academy's traditional views on painting.

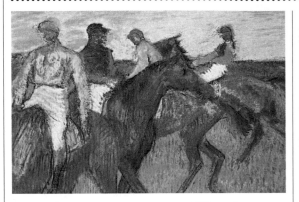

E. Degas (1834–1917). Horseraces (1877), pastel. Musée d'Orsay, Paris.

• Transportation motifs such as trains and horse-drawn carriages.
• Racetracks.
• Scenes depicting cabarets and brothels.

Photographic Cropping

Photography, which had a particularly important influence on the way images were framed, introduced artists to perspectives to which they were unaccustomed:
• Shortened foregrounds.
• Aerial or bird's-eye views.
• Depth perspectives that change the focal point of the painting.

The Photographic Model

The Impressionists' use of photography offered several new possibilities for pictorial composition:
• Capturing a moving object.
• Using several photographic

Impressionist Themes and Influences

The formation of the Impressionist group led artists to a new appreciation of themes that had traditionally been considered sordid or vulgar. Interest in pictorial effects achieved thanks to new developments in photography also grew. Impressionist themes included:
• Urban and rural landscapes, always depicting subjects from real life.
• Intimate scenes, portraying subjects who challenged the viewer.
• Festive and crowd scenes, depicting people far removed from Watteau's courtesan figures.

Caricature by Daumier of the photographer Nadar in his balloon.

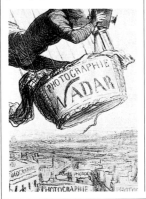

Aerial photograph of Paris taken by Nadar from a balloon. This new perspective greatly interested the Impressionists.

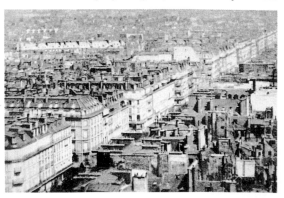

images in the composition of a painting, enabling the artist to paint a scene different from the actual model.

• Introducing into paintings different effects of light, which only a photograph could capture, such as sharp contrast of shadows, saturated light, and blurred background images.

Horses and People without Legs

The use of photography often helped painters capture an instantaneous view of images. Painters used photographic images to understand a subject in a more synthetic way. For example, in a synthetic image, a person approaching from a distance would appear as a spot in which only the moving leg is visible; similarly, a running horse would appear to have two or three legs, as portrayed by Degas and Monet, rather than four.

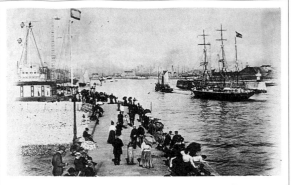

The photographic image provided new pictorial options. Photograph of Le Havre.

The Japanese Print

In their search for new themes, Impressionist painters became very interested in Japanese prints that were introduced to the West in the middle of the nineteenth century. Because they were relatively inexpensive, several artists in Manet's circle became avid print collectors. Utamaro (1753–1806) was one of the great artists who influenced Impressionist and later painters. Following are the features of Japanese prints that had the most impact on the Impressionists:

• Disregard for rules of Western perspective.

• "Snapshop cropping" of the main subjects of a scene. (Degas was particularly impressed by this feature.)

• Portrayal of scenes from everyday life.

• Use of aerial compositions.

• Introduction of an informal quality into paintings, as evident in Japanese prints depicting work scenes.

G. Caillebotte (1848–1894), Boulevards Seen from Above, oil on canvas.

K. Utamaro (1753–1806), Melancholic Love, print, private collection.

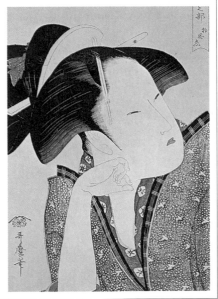

THE IMPRESSIONIST GROUP

The Impressionist group was not a closed group of artists who adhered to a fixed set of artistic beliefs. Rather, it was a collection of antiestablishment artists who moved in and out of the group, freely exchanging ideas. It was from this group that the first avant-garde movements emerged.

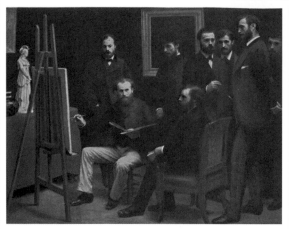

H. Fantin-Latour (1836–1904). A Studio in the Batignolles Quarter (1870), oil on canvas. Musée d'Orsay, Paris. This work shows the principal painters and intellectuals associated with the first Impressionist group. Only Morisot, Pissarro, Sisley, and Cézanne are missing from the group. Shown from left to right are Schölderer, Manet, Renoir, Astruc, Zola, Maître, Bazille, and Monet.

The Avant-Garde and the *Isms*

The Impressionist contribution to art history was significant for its subsequent development of new artistic movements. The word avant-garde has military connotations; in fact, the avant-garde refers to those on the front lines of a battle. Thus, the first artistic movements to break away from established norms at the end of the nineteenth century and well into the twentieth century are deservedly called avant-garde. Beginning with the Impressionist revolution, avant-garde artists launched a multitude of movements that quickly began to overlap (some dates are approximate, since many artistic movements intertwined with each other before becoming well defined): Impressionism (1863), Postimpressionism and Divisionism (1880), Fauvism (1905), Symbolism (1886), Expressionism (1905), Cubism (1907), Suprematism (1915), and Surrealism (1920). As each artistic movement emerged, theoretical and aesthetic positions were developed to justify its evolution and opposition to the preceding one.

Impressionists

Impressionism is not a well-defined artistic movement, nor did all of its members adhere to its principles throughout their careers.

There are very few pure Impressionist painters; most members of the group developed different artistic views. The Impressionists were united by their strong desire to exhibit their works and by several shared ideas about painting.

Evolution of the Group

1860–1870—Formation of the first nucleus around Monet: Renoir, Sisley, and Bazille.

1865–1870—First gatherings at the cafés in Montmartre and in Bazille's studio.

1870–1872—A second nucleus joins the group: Pissarro, Cézanne, Monet, and Guillaumin.

1872–1874—A third nucleus joins the group: Degas and Manet. Critics such as Duret and

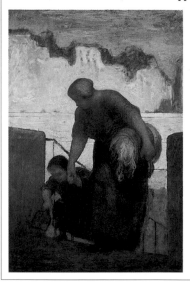

H. Daumier (1808–1879), The Washerwoman, oil on canvas, 13.2 × 19.3 in. Musée d'Orsay, Paris. The search for views seen against a backdrop of light and for themes from everyday life were the goal of several Impressionists.

Rivière attend the gatherings.

1874—First independent exhibition of the artists at the photographer Nadar's studio.

1876—Gauguin exhibits with the Impressionists, though he was considered a novice.

1877—First publication (short-lived) of *L'Impressionniste,* a magazine supported by the Impressionist dealer Durand-Ruel.

• A total of eight Impressionist exhibitions are held: 1874, 1876, 1877, 1879, 1880, 1881, 1882, and the last one in 1886 in which Seurat participates.

1886—The Impressionist group dissolves.

• Monet continues with Impressionist theory.

• Pissarro is the only artist who participated in all eight exhibitions.

• Manet continues to remain aloof from the Impressionist group.

Basic Impressionist Theories

It is dangerous to precisely define the principles of a group characterized by the individuality of its members. Instead, the principles should be presented and understood as a series of general concepts:

• Denial of academic learning provided in schools, though Renoir, Degas, and Manet had strong academic backgrounds.

• Opposition to Romantic principles that defined artistic expression as the subjective manifestation of the artist's feelings.

• Replacing imaginative art with face-to-face encounters with the models to be painted.

• Adhering to objective and scientific principles in painting.

• Championing of Realism as a concept dealing with the analysis of reality, without regard for social or economic impacts.

• Greater interest in the interplay of light on a subject than in the subject itself.

• Use of varied techniques and ideas for studying light.

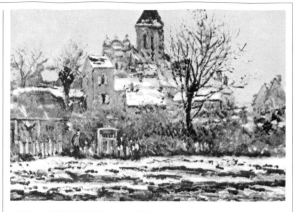

C. Monet (1840–1926), Church at Vétheuil in Snow. *Musée d'Orsay, Paris. As can be seen in this landscape, the effect of light on objects is primary.*

C. Pissarro (1830–1903). Le Pont Neuf. *Private collection, Philadelphia. Their interest in capturing the fleeting effects of light led Impressionist painters on a continuous pictorial quest.*

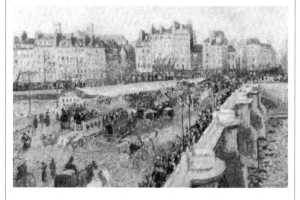

J. A. Whistler (1834–1903), Caprice in Purple and Gold, No. 2, The Golden Screen *(1864), oil. Musée d'Orsay, Paris. The influence of Oriental art is clearly seen in the works of many Impressionist painters.*

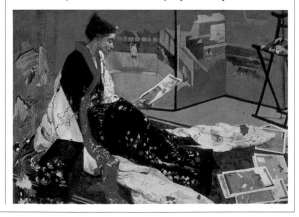

NEO-IMPRESSIONISM AND POSTIMPRESSIONISM

Impressionism was characterized by the strong individualism of its members; as members postulated their own artistic views, different trends arose as a reaction to Impressionism itself. Thus, Neo-Impressionism was as much a consequence of the evolution of Impressionism as a reaction to it.

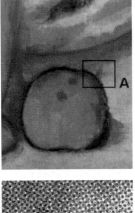

The principles of Pointillism derive from the physics of color and the way the human eye captures it. The theory of Divisionism can be understood from these images: Box A in the top picture appears magnified in the bottom picture; one can see how the colors are broken down into points of basic colors.

Characteristics and Evolution of Seurat's Neo-Impressionism (Pointillism or Divisionism)

Seurat came in contact with the Impressionists and exhibited his work *Sunday Afternoon on the Island of La Grande Jatte* (1884–1886). Seurat's innovations in this work represent both a summary of Impressionistic scientific techniques as well as an explosive approach to painting.
• Exhaustive analysis of reality that rejects Naturalism.

• In-depth study of the laws of physics relating to color.
• Investigation into the effects of light and color on the retina.
• Psychological study of the direction of lines in painting: horizontal lines impart a sense of calm to the viewer; inclined vertical lines, happiness or sadness; zigzag lines, nervousness or excitement.

The Postimpressionists

The pictorial reactions of Postimpressionist artists resulted in the development of different ways to escape from Naturalism. Seurat developed Divisionism. Cézanne was interested in pictorial structure, paving the way for the beginning of Cubism. Gauguin decided to break with Naturalism by using a simple line and flat colors. Van Gogh's style culminated in the Expressionist trend. Toulouse-Lautrec developed interest in graphic and poster art, and developed a thematic depicting scenes from cabarets and the world of entertainment.

G. Seurat (1859–1891), The Parade (1888) (fragment). Metropolitan Museum of Art, New York. The artist uses the psychic effects of line and color in his painting.

Characteristics of Postimpressionist Trends

Paul Gauguin:
• Exoticism and symbolism in the subjects.
• Inspiration from ancient and primitive sites.
• Flat colors.
• Pure chromatic technique.
• Unnatural treatment of colors.
• Resurrection of old techniques for making prints (xylography).

A. Derain (1880–1954), The Bridge at Westminster, *oil on canvas. Private collection, Paris. Gauguin's work had a great influence on the later generations of Nabis and Fauves.*

P. Gauguin (1884–1903), Les Alyscamps, Arles, *(1888), oil on canvas, 28 × 36 in. Musée d'Orsay, Paris. The parallel between this work and Derain's is obvious in the composition, flat colors, and masses of color.*

Nabis (a group of French painters who used Gauguin's work as a benchmark including Sérusier, Denis, Bonnard, Vuillard, Maillol before he became a sculptor):
• Interest in using color as a decorative and emotive device.

Paul Cézanne (did not identify himself with the Impressionists):
• Interest in analyzing the structure of nature.
• The same portraits, landscapes, and still lifes seen from different points of view.
• Creation of the third dimension relying on planes of different tonal variations rather than on perspective.

Vincent van Gogh:
• Landscapes, rural themes, portraits, and taverns.
• Set aside social realism for an emotive approach to reality.
• Symbolic appraisal of colors through the touch of the brushstroke.
• Definition of forms with vigorous brushstrokes (influenced by Seurat's Divisionism).
• Aggressive, juxtaposed colors. Abstract use of color and optical realism.

The Spread of Impressionism to Other Countries

Impressionism evolved and subdivided into a number of currents that gave name to the vanguards. Different Postimpressionist movements grew throughout Europe and America.
• Expressionism, which evolved from the works of van Gogh, took root in Germany beginning in 1911; the term was used to describe an exhibition in Berlin of Fauvist and Cubist works.
• The Fauve movement took hold in Norway and in France.
• From techniques developed by Cézanne, Picasso developed Cubism, the first bulwark of abstract art that influenced the Russian artist Kandinsky.

Van Gogh (1853–1890), Haystacks *(1888). Rijksmuseum Kröller-Müller, Otterlo. The expressive force and chromatic capability of this artist paves the way for the development of the Expressionist trend.*

Cézanne (1839–1906), The Blue Vase. The Louvre, *Paris. Cézanne paved the way for the later development of Cubism.*

THE EVOLUTION OF IMPRESSIONISM

The work of artists who were closest to, but not directly part of the Impressionist movement, created an environment in Paris that encouraged the diffusion of different avant-garde ideas in the field of fine arts. On one hand, the critical debate carried out in the conservative press kindled the creative fires of the most bohemian and rebellious of the artists; on the other hand, the artistic environment (café gatherings, the support of poets and writers) further encouraged expansion of the new trends.

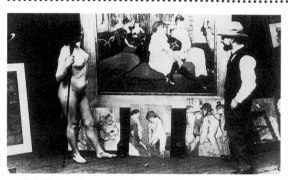

H. de Toulouse-Lautrec and his model in front of the artist's works.

Toulouse-Lautrec and Art Nouveau

Shortly after the dissolution of the Impressionist group, a new ornamental art emerged as a reaction to the historical themes prescribed by the Academy. This art, which became known as Art Nouveau, relied on the use of vegetable motifs and on pre-Raphaelite influences. Exerting a great impact on the evolution of pictorial and graphic arts, this trend captured the attention of top masters in drawing such as Toulouse-Lautrec. Much of Toulouse-Lautrec's work was based on his aesthetic preference for line over color.

Distinctive elements of Toulouse-Lautrec's work are:
• Strong emphasis on circus, brothel, and c a b a r e t themes.

The Japanese print was important in understanding the role of line, figure, and composition.

• Direct influence by Japanese prints.
• Use of lines to simplify images.

Gauguin's Role

Gauguin embraced Impressionism only to reject it later. The art form he developed was called *Synthesism.* Gauguin's break with the group allowed him to exercise his creative freedom and to form the basis of a new school.

Flat colors, accentuated tones—including the use of complimentary colors—and lines separating the different compositional planes led to Fauvism and Nabism. These schools produced artists such as Ma-

P. Gauguin (1848–1903), Vairumati (1897), oil on canvas, 29.7 × 37 in. Musée d'Orsay, Paris. Gauguin had a very important role in the development of vanguard art in the twentieth century.

tisse, Vuillard, Bonnard, and several others whose theories on color blendings and creative forms evolved into hundreds of different and complex *isms* in the twentieth century.

Consequences of the *Isms* in the Twentieth Century

With the evolution of the different trends that emerged in the Postimpressionism era came new conceptions of fine and aesthetic art.

• After the Fauvist exhibition held in 1905, the movement continued to expand and absorb a mix of new aesthetic and theoretical ideas.

• The Nabis, clearly influenced by Gauguin, prompted a colorist flourishing that German Expressionism channeled into instinctive and emotive forms caused by the crises of the world wars.

• The ideas developed by Cézanne are clearly evident in Picasso's work, which translated the study of planes of different focal depth into what is called Cubism.

• The impact of artistic innovations that were developed by various groups rooted in Expressionism, as in the example of the *Blue Rider*, paved the way for Kandinsky's first abstract work.

• The evolution of Nabis art form and the Dada crisis gave birth to the development of Pop Art in the 1960s.

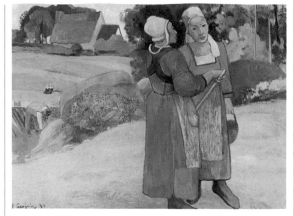

P. Gauguin (1848–1903), Breton Peasant Women *(1896), oil on canvas. Musée d'Orsay, Paris. Sketched line and color are dominant in the rendition of the figures. These features were later (1905) adopted by Fauvism.*

Luxury, Calm, and Voluptuousness *(1904–1905), oil on canvas, 38 × 46.5 in. Musée d'Orsay, Paris. H. Matisse (1869–1954) was one of the most eclectic artists of the twentieth century. He was influenced by Seurat (Pointillism), but eventually became one of the principal representatives of Fauvism.*

W. Kandinsky (1866–1944) Yellow, Red and Blue. *Musée d'Art Moderne, Paris. The development of diverse Expressionist influences that culminated in the works of van Gogh led to the emergence of abstract art.*

Andy Warhol (1930–1987), Marilyn. *Private collection. Gauguin's influence on Pop Art is evident in this painting with its color planes separated by lines.*

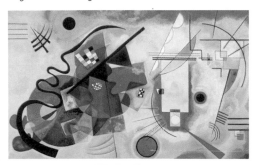

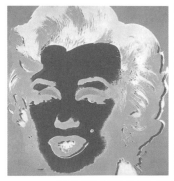

THE ARTISTS

FRÉDÉRIC BAZILLE

Friend and patron of the artists, member of the first Impressionist group. Although he painted open-air landscapes with Monet, Renoir, and Sisley, Bazille is best known for his figure paintings. His death in the Franco-Prussian war brought to an end his notable influence on the group, and what otherwise might have been a brilliant artistic future.

Bazille, Self-portrait. *Pencil drawing.*

Influences

• Was fascinated by Delacroix's depiction of Oriental scenes.
• Adopted Renoir's pleasing way of treating forms.
• Adopted Monet's technique for endowing human figures with a luminous, flesh-colored tint.
• Was influenced by Courbet's realism, particularly in his choice of subject matter.
• Provided financial support to Courbet.
• Because of his untimely death, he did not significantly influence other artists. His loss was quickly overcome by continuous exhibiting by the Impressionists. The comings and goings of artists within the Impressionist group, which was never closed, enriched the creative expression of the entire group.

LIFE OF THE ARTIST

1841—Born in Montepellier to a wealthy family.
1862—Arrives in Paris; enters Gleyre's studio where he meets Monet, Renoir, and Sisley.
1863—With his group of friends, he visits Manet's exhibition at the Martinet Gallery. The group chooses Manet as their leader at the Salon des Refusés.
1865—Becomes a member of the avant-garde group that meets at the Café Guerbois. Soon thereafter, he meets Cézanne, Manet, Fantin-Latour, Pissarro, and Guillaumin.
1868—Shares an apartment-studio with Renoir for two years.
1869—Hangs black curtains in his studio, which enables him to better concentrate on his work; works on several paintings at the same time.
1870—Dies on the front in the Franco-Prussian War at the battle of Beaune-la-Rolande at 29 years of age, ending a promising career.

Technical Characteristics

• An exceptionally talented sketcher, he perfects the human figure and the rough sketch.
• Displays a dominance of space in the composition of background and figures.
• Uses large masses of color with flat tones, without direct brushstrokes.
• Establishes different situational planes using simultaneous contrasts.
• Alternates modeled forms with flat masses, emphasizing color and its directional focus.
• Alternates pure, brilliant colors with highly detailed workmanship.
• Subtly integrates background figures, without overly abrupt contrasts.
• His portraits of fellow painters are fresh and spontaneous. In them he alternates sketching with painting, always eliminating precise contours or direct paint smudging.

Themes

• Considered mainly a painter of human figures specializing in interior scenes.
• Strives to capture the uniqueness of models by presenting everyday subjects in unusual poses.
• Prefers groups of people in his interior scenes, both in those depicting routine meetings at his studio and in his more intimate scenes.
• Treats the female figure delicately, incorporating Oriental elements such as silks, bro-

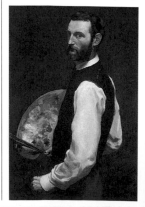

Self-portrait with Palette *(1865),* oil on canvas, 28.4 × 42.5 in. *The Art Institute of Chicago.*

The Makeshift Ambulance (1866), oil on canvas, 25.6 × 18 in. Musée d'Orsay, Paris.
Portrait of Pierre Auguste Renoir (1867), oil on canvas. 20 × 24.1 in. Musée des Beaux-Arts, Argel.
The Walls of Aigües-Mortes (1867), oil on canvas, 21.7 × 18 in. Musée Fabré, Montepellier.
Bathers (Summer Scene) (1869), oil on canvas, 62 × 62.5 in. Fine Arts Museum, Harvard University, Cambridge, Massachusetts.

cades, or decorative motifs.
• Delights in the bourgeois environment of meetings with his friends.

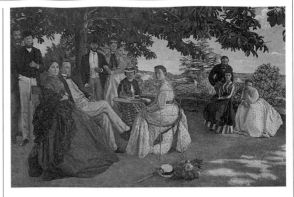

Family Reunion *(1867), oil on canvas, 90.5 × 59.8 in. Musée d'Orsay, Paris. As with C. Monet's* Luncheon on the Grass *or Whistler's* Women in the Garden, *this work displays a special new vision of light and color, searching for real harmony between man, nature, and, especially, the enveloping light.*

The Artist's Studio, 9 Rue de la Condamine *(1870), oil on canvas, 50.4 × 38.6 in. Bequeathed by Marc Bazille. Musée d'Orsay, Paris. In this work, one sees a gathering of friends at the painter's studio. Visible in the background is the unfinished* The Toilette; *to the right a table that Bazille bought from Manet; above is Renoir's framed* Landscape with Two Persons. *Curiously, Bazille, the tall figure in the center, was painted by Manet. Other identifiable figures in the painting are Edmond Maître at the piano, and É. Manet wearing the hat. The other three men are probably C. Monet, A. Zola, and A. Sisley.*

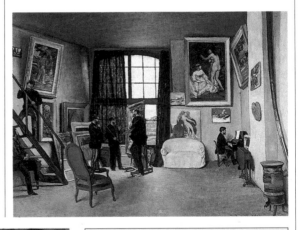

I believe that in painting the scene in itself is relatively unimportant. What is important, however, is that what is painted be done so in an interesting fashion from a painterly point of view.

The Toilette *(1870), oil on canvas, 79 × 83.1 in. Musée Fabré, Montpellier. This painting, rejected by the 1870 Salon, depicts an intimate scene with a group of three women. Two of the women carefully attend to the third as if she were an Odalisque. The cross-cultural influence is clearly visible in the painting. The fabrics in the painting indicate different origins. The squatting woman with uncovered torso and covered head is African; the other woman is wearing an embroidered silk shawl, probably from Manila or China; the wall is covered with a carpet, most likely Persian. The overall effect is one of great richness in terms of pictorial art, textures, light, and exoticism.*

PIERRE BONNARD

Painter and graphic artist. Within the Postimpressionist movement, Pierre Bonnard with Sérusier and Denis clearly demonstrate Gauguin's legacy of pictorial principles developed by the Nabis. He was one of the principal founders of the Salon d'Automne, where the Fauves exhibited regularly.

LIFE OF THE ARTIST

1867—Born in Fontenay-aux-Roses, near Paris.
1888—Studies at the Académie Julian where he meets Sérusier, Denis, and other disciples of Gauguin.
—Meets Vuillard at the École des Beaux-Arts, with whom he later develops *Intimisme.*
1891—Begins to exhibit regularly at the Salon des Indépendants; reaches artistic maturity after joining the Nabis group and adopting their approach to handling colors.
1903—Founding member of the Salon d'Automne, organized by the Fauves.
1940—Becomes a widower; falsifies his wife's will. The Royal Academy makes him a member.
1947—Dies at Le Cannet. Many of his exhibited works are withdrawn because of legal problems resulting from his 1940 fraud act.

Pierre Bonnard.

matches that of Toulouse-Lautrec.
• Thematic references to Renoir can be observed in his interior studies with figures.
• Bonnard's most colorful work acquired an expressive, almost expressionistic quality reminiscent of van Gogh in his use of yellows, reds, and blues.
• Several of Bonnard's paintings are reminiscent of Degas in both composition and conception; however, his intimate scenes are especially related to the work of Mary Cassat.

• Pissarro's influence is also seen in Bonnard's works.
• Reciprocal thematic and technical influences between Bonnard and Vuillard are also noted.

Technical Characteristics

• Expresses aesthetic experiences in a refined style that is always conventional and uncompromising, thus avoiding any possible attack by critics or the public.
• Uses short brushstrokes to create thick blendings of color that form textured surfaces.
• Alternates textured areas with entirely flat areas of color.
• Uses pure color, different levels of perspective, and simultaneous contrasts.
• Captures all vibrations of light, toying with a kind of Pointillism.
• Unaffected by the influences of his time, develops works inspired by Fauvism and Cubism.
• Beginning in 1928, dissolves forms into patches.
• By the end of the 1930s, develops a coloristic style.
• Produces works that radiate a sense of comfort and well-being.

Influences

• Clear influences came from Gauguin in his appreciation for large-scale patterns of flat colors, but without the heavily outlined figures.
• Japanese prints unleashed Bonnard's graphic talent, which

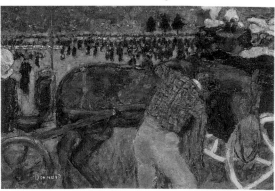

The Bullfight, *oil on canvas. Musée d'Orsay, Paris. All of Bonnard's work is characterized by enormous poetic power.*

Women in the Garden (1892), group of panels, 30.8 × 63 in. each. Musée d'Orsay, Paris.

Dusk (The Croquet Game) (1892), oil on canvas, 64 × 51.2 in. Musée d'Orsay, Paris.

The Bullfights of Longchamp (1897), tryptich. Private collection.

Provenzal Conversation (1911), oil on canvas, 79 × 50.8 in. Modern Gallery Collection, Prague.

Dining Room in the Country (1913), oil on canvas, 80 × 63 in. Minneapolis Institute of Arts.

The Cannes Port (1922), oil on canvas, 15 × 13 in. Musée de l'Annonciade, Saint-Tropez.

• Becomes the most distinguished representative of the Impressionist movement.

Themes

• Intimate and street scenes.
• The figure of the woman is the dominant theme in his work.
• During the last years of his life, from his window he paints landscapes that are often imbued with great lyricism.
• Paints still lifes with intense chromaticism.

Woman with a Cat (1912), oil on canvas, 30 × 30.7 in. Musée d'Orsay, Paris. The masses of flat color are broad and take up most of the space in the painting, which shows the table in false perspective. The table is shown in the first plane from an almost top-down perspective.

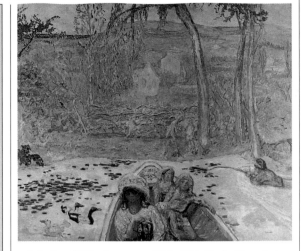

In the Boat *(1907), oil on canvas, 118.5 × 109 in. Musée d'Orsay, Paris. A pleasant landscape displaying a broad chromatic scheme, in which pastel tones depict a leisurely scene in a nature setting. Disregard for formal outlining of forms combines with a use of color that is mixed directly on the canvas. Fauvist influences are seen in the lake's large flat mass of color and in the delineation of the boat's contour.*

In any pictorial work, harmony constitutes a more solid basis than observation, which can often be deceiving.

José-Bernhein, the Younger, and Gaston Bernhein de Villiers *(1920), oil on canvas, 61 × 65 in. Musée d'Orsay, Paris. This interior scene portrays an office with two figures. The space is scrupulously rendered so that the relationship between the different structures does not cause claustrophobia. The person at the bottom of the painting takes up most of the foreground, while the perspective and focal point lie with the second figure. The painting makes use of a vibrant chromatic scheme that alternates large flat areas with luminous patches.*

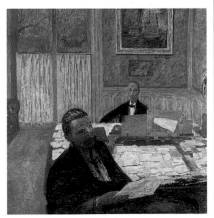

EUGÈNE BOUDIN

A landscape painter, Boudin greatly influenced Monet
to paint in the open air. Thus, he is considered the main link between
the painters in Corot's group and the Impressionists.

Eugène Boudin.

Influences

• Received encouragement from Millet to begin painting.
• Discovered vibrations of light in painting thanks to Jongkind.
• Inspired a young Monet to paint outdoors.

Technical Characteristics

• Uses free and direct brush-strokes.

• Shows expressiveness in the design of his work.
• Alternates contoured figures or shapes with poorly defined and imprecisely drawn ones.
• Paints quickly, without clear definition of form.
• Uses pure colors without gradations in shadow.
• Alternates simultaneous contrasts to define figure planes.

Themes

• His most important work contains beach and coastal scenes of the English Channel.
• His skies were greatly admired by the Impressionists, with whom he exhibited at their first exhibition held in 1874.
• The fog in his landscape paintings stands out for its almost transparent, mother-of-pearl quality.

LIFE OF THE ARTIST

1824—Born in Honfleur, the son of a sailor, which influences his obsession with the sea.
—Begins to paint as a young man. Works as an editor in Le Havre.
—With a partner, opens a shop where he organizes exhibitions and sells artists' materials.
—Through his business, meets Troyon, Couture, Isabey, and Millet.
1847—Travels to Paris, to the north of France, and Belgium.
—The Société des Amis des Arts in Le Havre awards him a three-year scholarship to study in Paris.
1858—Meets Monet and encourages him to paint outdoors.
1859—Participates in the Salon; his work is praised by Baudelaire.
1861—Becomes Troyon's assistant and maintains a close relationship with Corot.
—Paints in Honfleur with Jongkind and Monet.
1883—Durand-Ruel organizes a successful Boudin exhibition in his gallery.
1895—Travels continuously to Italy, Holland, and France.
1898—His wife dies and his health deteriorates. He finds himself increasingly alone and dies a short time after becoming widowed.

*The Beach at Trouville (1863), oil on canvas, 18 × 10 in.
The Metropolitan Museum of Art, New York. An open-air painting,
a masterpiece of modern painting produced by an artist of the first
vanguard who was a lover of nature. Boudin's interest in light led him
to a realist study of light, which influenced both the Realists
and the Impressionists.*

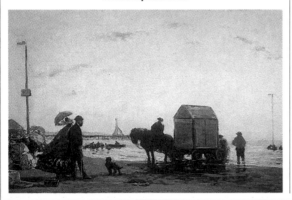

E *Boudin*

Beach at Trouville *(1863), (detail). This painting shows precise brushstrokes and a great synthesis in the exposition of forms that are translated as small planes.*

Interior view of the Salon at the Durand-Ruel gallery. Boudin's work was admired by both the public and the critics at the 1883 exhibition held at this Salon.

Woman in White on the Beach at Trouville *(1869), oil on board, 20 × 12.5 in. Museum of Fine Arts, Le Havre. Open-air painting was one of the Barbizon School's contributions to Impressionism. Painting from nature rather than in the studio was one of the principles of the modern painter. The central figure is presented in a direct, concise manner, while the background figures have been portrayed in a series of quick, precise patches.*

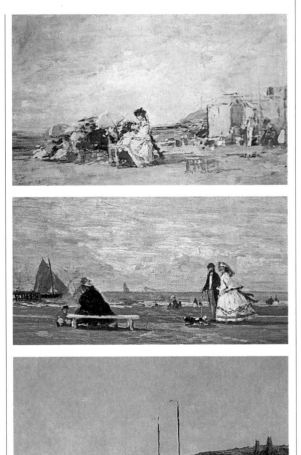

Beach at Trouville *(1863), oil on board. The chromatic synthesis used by Boudin greatly interested the Impressionist painters. The forms, while barely drawn, are defined through patches of color that erupt against a background that has been carefully studied in terms of the enveloping light.*

Beach at Trouville, *(1864), oil on board, 19 × 10.5 in. Private collection, Paris. Notable in this work is the natural quality of the figures, which have been rendered with rapid brushstrokes. Highly luminous planes alternate with darker ones. The large mass of figures dominating the center of the painting stands out against a wide background depicting a low horizon. The sky occupies most of the painting and gives the painting a luminous atmosphere, rich in hues.*

GUSTAVE CAILLEBOTTE

Caillebotte was a very important figure in the Impressionist movement, more as a collector than a painter. Nevertheless, he produced outstanding works that earned him a well-deserved place among his Impressionist friends. Because of his comfortable economic position, Caillebotte was often able to act as an influential patron for his group of friends. He participated in five Impressionist exhibitions but never embraced any of the different styles that evolved.

Self-Portrait *(1889).*

Young Man at the Piano (1876), private collection.

Man in a Café (1876), Musée de Rouen.

European Square (1877), The Art Institute of Chicago.

Painters on the Scaffold (1877), private collection.

The Garden at Gennevilliers (1893), Private collection.

LIFE OF THE ARTIST

1848—Born in Paris to an upper-class family; his comfortable economic position allows him to serve as influential arts patron for the Impressionist group.

1873—His father dies, leaving him a large fortune. A friend of Bonnat, he enters the École des Beaux-Arts.

1875—His work is rejected by the Paris Salon and he leaves the École des Beaux-Arts.

1875—He becomes friendly with Degas, Bonnat's friend, and through Degas with the Impressionist group as well.

1876—Participates in Impressionist exhibitions as an organizer.

1881–1886—Decides not to participate in the group's exhibitions because of discord within the group.

1876—Names Impressionist friends as beneficiaries in his will.

1887—Settles permanently at Petit-Gennevilliers, near Argenteuil.

1888—Exhibits at Durand-Ruel's gallery.

1890—Is one of the petitioners trying to get Manet's *Olympia* into the Louvre's permanent collection.

1894—Dies at Gennevilliers. Bequeaths his works to the state, leading to a great debate among the members of the Academy. Many of his works are installed at the Luxemburg Museum in 1896.

Influences

• Caillebotte's main works have a strong realist basis.
• His Impressionism was preceded by a naturalism reminiscent of Millet in his glorification of humble people and of Courbet in his portrayal of realistic figures.
• Was influenced by all of the members of the Impressionist group, but did not embrace any one particular style.
• From Monet he learned how to capture the energetic quality of light shining on objects.
• Like Pissarro, he tended to mix colors on the canvas, and used small, dry strokes that left visible brushmarks on the canvas.

Technical Characteristics

Characteristics of Caillebotte's varied stylistic stages include:
The Realist Period:
• Naturalist modeling of figures.
• Precise outlining of forms.
• Concern for realistic representation of light by observing its directional path and impact on the surface it illuminates.
• Careful maintenance of chromatic harmony, using the appropriate range of colors in each painting.
• Photography influences him in his study of the effects of light on bodies.
The Argenteuil Period:
• Impressionist application of colors; study of local and tonal light.
• Replacement of modeling with direct brushstrokes; use of vibrating brushstrokes to apply pure color.
• Elimination of precise outlining of forms.

G.Caillebotte

Paris on a Rainy Day *(1876–1877)*,
*oil on canvas, 109 × 83.5 in. Worcester
Foudel. Caillebotte's work often
displays Impressionist characteristics,
though he never embraced any of the
group's styles. The theme here is
consistent with the artist's search for
the unusual. The painting is as much a
study in photographic cropping as
of the treatment of light on objects on a
rainy day. References to Degas' work are
found in the effect of rain and in the
handling of the theme.*

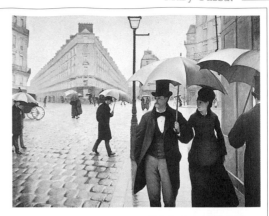

The Floor Scrapers *(1875),
oil on canvas, 75.6 × 57.5 in.
Musée d'Orsay, Paris. This
work was exhibited at the
Second Impressionist
exhibition held in 1876. Its
importance lay in the
modernity of the theme,
viewed objectively without
any attempt to dignify the
humble task as Millet in his
time had done. The work
represents a perfect study in
spatial composition, creating
an interesting effect through
the perspective of the floor.*

Themes

• Caillebotte's favorite themes are
city views, still lifes, and boats, al-
though he also painted interior scenes.
• After a period of naturalism in
which he painted mainly city scenes
with unusual perspectives, his best
Impressionist stage corresponds to
the Argenteuil period, in which he
painted only seascapes.

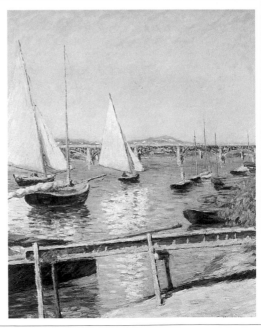

Sloops in Argenteuil *(1888),
oil on canvas, 22 × 26 in. Musée d'Orsay,
Paris. The harbor view seen from the
painter's house in Gennevilliers
reflects a well-balanced, luminous
composition. The railroad bridge can be
seen in the background and, to its right,
Argenteuil. The treatment of forms, light,
and water reflections achieved through
direct brushstrokes of pure color are
representative of the Impressionist style.*

MARY CASSAT

Mary Cassat exhibited with the Impressionist group due to the influence of Degas. She is important for her revival of intimate scenes in painting. Born into a well-to-do family, Cassat was able to influence her wealthy North American friends to buy Impressionist paintings.

Mary Cassat.

Influences

• Early influences came from the work of Courbet.

• Was largely influenced by Degas in her handling of form and line, but her personal touch makes her work distinguishable from others.

• Renoir's approach to handling pastels is evident in many of her colorist works.

• Was influenced by Japanese paintings, particularly prints, in

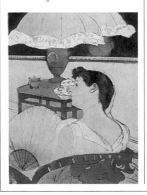

LIFE OF THE ARTIST

1845—Born in Pittsburgh, Pennsylvania, the daughter of a banker who strongly opposes her choice of art as a career.

1868—Travels throughout Europe, visiting major museums and copying the classics.

1870—Settles in Paris to study at the studio of the academic painter Chaplin.

1877—Meets Degas in the Louvre Museum; he invites her to exhibit her works with the Impressionists.

—Her comfortable economic position enables her to buy many paintings done by her fellow artists, often helping the dealer Durand-Ruel.

1912—Becomes partially blind.

1914—Stops working altogether, but maintains contact with her fellow painters.

1914—Receives a medal of honor from the Pennsylvania Academy.

1926—Dies at Le Mesnil Théribus.

her drawing and printmaking techniques.

• In her most authoritative works, such as her sketches, Monet's theories on light are somewhat perceptible.

• Had a significant influence on Bonnard and Vuillard in their treatment of intimate scenes.

Technical Characteristics

• Impressionism for Cassat implies a search for themes from everyday life, not a process of plastic synthesis, as understood by the other artists in the group.

• Portrays carefully modeled figures, usually without the flat colors used by her fellow painters.

• Does not use pure colors or free brushstrokes; produces paintings with an elaborate finish.

The Lamp (1891), print, drypoint and aquatint. The National Gallery of Art, Washington.

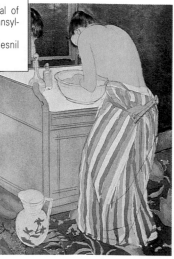

Woman Washing Herself (1891), print, drypoint and aquatint. The National Gallery of Art, Washington. Cassat delighted in themes from everyday life.

• Though she prefers drawing, she is a master of all pictorial techniques.

Themes

• Paintings deal mainly with everyday subject matter.
• Her interior studies portraying maternal and family scenes are brilliantly developed and convey a tender, as opposed to crass, quality.
• Portrays scenes depicting strolls in the park, boats, and leisure activities, always in a relaxed, carefree setting.
• An element of refinement characteristic of the upper class is evident in all of her work.

> One of the things about which I am truly enthusiastic is visiting exhibitions of Japanese prints.

At the Theater (1880), oil on canvas. Museum of Fine Arts, Boston.
The Young Bride (1875), oil on canvas. Montclair Art Museum, New Jersey.
The Cup of Tea (1879), oil on canvas. Metropolitan Museum of Art, New York.
Woman Driving with a Child (1879), oil on canvas. Philadelphia Museum of Art.
Miss Mar Ellison (1880), oil on canvas. The National Gallery of Art, Washington.

Child Combing Her Hair *(1886), oil on canvas, 24 × 29.5 in. The National Gallery of Art, Washington. Degas's influence is visible in the aesthetic treatment of this work, but a personal rift in their relationship prompted her to change her approach to painting. Modeling of forms is subtle, but the work reveals a series of direct brushstrokes and pure colors, particularly on the nightshirt's highly luminous areas.*

The Bath *(1891), stamped print, drypoint and aquatint, 9.8 × 13 in. The National Gallery of Art, Washington. This work is an example of how the Japanese print influenced the first vanguard. The conception of space, large monochromatic planes, simple lines, and the large print areas are typical of Mary Cassat's prints. This work clearly shows the artist's great talent for drawing.*

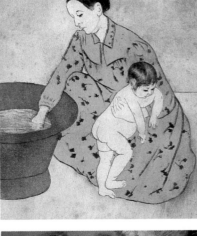

After the Bath *(1901), pastel, 39 × 25.4 in. The National Gallery of Art, Washington. Several versions of this theme exist, but this one is considered one of her best and most successful paintings. It represents a perfect mastery of several techniques within the same painting, where barely outlined areas alternate with others that are perfectly finished. The flesh tones are extremely delicate, revealing an Impressionist rendition of color highly influenced by Renoir.*

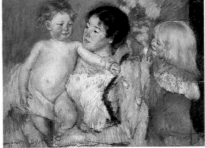

PAUL CÉZANNE (I)

Together with Gauguin and van Gogh, Cézanne is a main exponent of Impressionism. His artistic innovations, which Picasso used to develop Cubism, make him one of the most important influences on twentieth-century art.

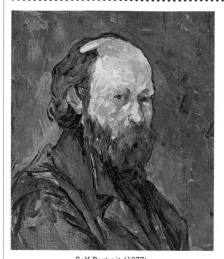

Self-Portrait *(1877)*.

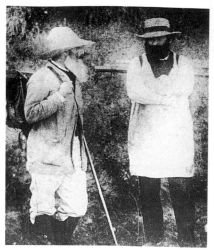

Pissarro and Cézanne, photograph taken about 1872.

Influences

• Cézanne's works from his first phase are heavily imbued with romantic elements, characterized by a high level of fantasy and sensuality inspired by the paintings of El Greco, Tintoretto, and Zurbarán.

• After visiting the Salon des Refusés in 1863, he became an ardent admirer of Manet. One of his favorite activities was copying the works of Delacroix and Courbet.

• The time he spent working with Pissarro was a decisive element in his works. It was then that he first painted outdoors, lightened the colors on his palette, and took on obvious Impressionist influences.

• Cézanne's influence on later generations of artists was inevitable. Clear references to his works are found in the Cubism of Braque and Picasso and in Matisse's approach to color.

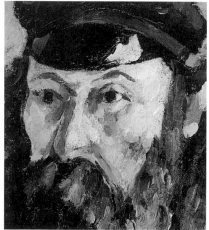

Self-Portrait in a Hat (1873–1875) (detail), oil on canvas. Hermitage Museum, Saint Petersburg. Typical in all of Cézanne's paintings is a brushwork that defines planes and gives structure to the work as a whole. Here Cézanne had already abandoned the Romanticism of the Impressionists in favor of simple linear lines and austere interpretations.

Technical Characteristics

• Cézanne typically uses labored brushstrokes in his works.

• Gives shape to forms using planes; achieves mass by carefully juxtaposing different tonal planes rather than using tonal gradations.

• Precise drawings give a highly structured appearance to his work, with lines separating the different planes. As his unfinished paintings show, he does not make preparatory sketches on the canvas.

LIFE OF THE ARTIST

1839—Born in Aix-en-Provence to a well-to-do family; never suffers economic hardship.

—Émile Zola (1840–1902), a school friend, introduces him to Manet and Courbet and encourages him to study in Paris.

1861—Meets Pissarro at the Académie Suisse.

1862—Meets Monet, Bazille, Sisley, and Renoir.

1872—Settles at Auvers-sur-Oise and works as an apprentice to Pissarro; has a son with Hortense Fiquet, but keeps the birth secret from his father.

1874 and 1877—Exhibits with the Impressionists, though he always maintains a distance from the group.

1886—Before his father's death, he marries the model Hortense Fiquet; inherits the family home at Jas de Bouffan when his father dies.

1895—Displays his works at a private exhibition organized by the dealer Vollard; is highly esteemed by the younger artists who call him the *wise one*.

1904—The Salon d'Automne holds a retrospective exhibition of Cézanne's paintings, which clearly influence later generations of artists.

1905—Finishes *The Large Bathers* after seven years of work.

1906—Dies in Aix-en-Provence after returning from an outdoor painting session. His study in Aix-en-Provence is converted, after his death, into the Cézanne Museum; part of his personal belongings are held there just as the artist left them.

1910—Exhibition organized by Roger Fry in England.

P. Cézanne

The Blue Vase (1883–1887), oil on canvas, 19.7 × 24 in. Musée d'Orsay, Paris.

Paul Cézanne in a Hat (1885), oil on canvas, 21.3 × 26 in. Musée d'Orsay, Paris.

The Kitchen Table (1888–1890) oil on canvas, 31.5 × 25.6 in. Musée d'Orsay, Paris.

Woman with a Coffeepot (1890–1894) oil on canvas, 38.2 × 51 in. Musée d'Orsay, Paris.

The Boy in the Red Vest (1890–1895), oil on canvas, 25 × 31 in. Bührle Collection, Zurich.

Four Women Bathers (1890–1894), oil on canvas 13 × 8.7 in. Musée d'Orsay, Paris.

Onions, Bottles, Glasses, and a Plate (1895–1900) oil on canvas, 32 × 26 in. Musée d'Orsay, Paris.

Joaquín Gasquet (1896–1897), oil on canvas, 21.3 × 25.6 in. Musée d'Orsay, Paris.

• In his later paintings, uses a shading technique that gives more importance to compositional structure than to subject matter.

• Unlike the other Impressionists, Cézanne's color scheme is not based directly on nature's colors.

• Alternates color with line, combining drawing and painting.

• Starts his paintings with a realistic treatment of form, which he then modifies and develops.

• Structures forms as geometric figures that are reduced to pure elements, such as cylinders, squares, or spheres.

Themes

• Unlike other Impressionists, Cézanne does not depict scenes that are directly observed in nature. Rather, he develops his themes based on a study of the different planes that give them shape. His wide range of themes includes still

lifes, self-portraits, and landscapes.

• One of Cézanne's favorite themes is the Mont Sainte-Victoire landscape, the motif of more than sixty of his paintings.

• Another favorite theme is the human figure. Here he develops many of his pictorial theories.

• Cézanne's still lifes present an in-depth pictorial study on the representation of all of the model's planes as geometric forms.

The Cardplayer *(1890)*, pencil drawing. One notes in this drawing a propensity to define the model's volume in a series of planes.

Cézanne in a photograph taken by Émile Bernard in 1905.

PAUL CÉZANNE (II)

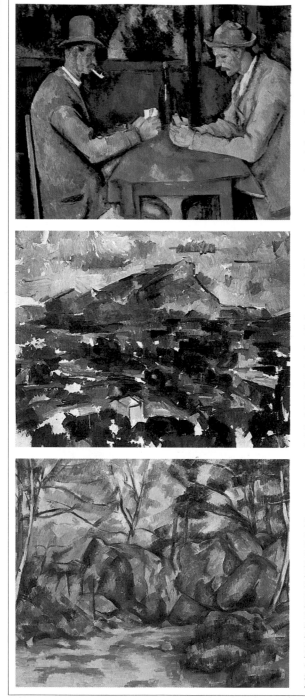

The Cardplayers (1890), oil on canvas, 22 × 18 in. Musée d'Orsay, Paris. The figures are unaware of their central role in the painting and are completely absorbed in their activity; the artist develops the theme and, at the same time, develops a technically complex language of color relationships between the different planes of the painting by alternating, in the same area, short brushstrokes and tonal changes, or by defining precisely drawn areas where patches of color always determine volume. The rich pictorial structure compensates for the detached quality of the figures.

Mont Sainte-Victoire (1904–1906), oil on canvas, 31.9 × 25.6 in. Musée d'Orsay, Paris. This painting shows one of Cézanne's more frequent themes. From his house, he produced numerous drawings and paintings based on the mountain, wherein he studied different planes observed when transferred to the canvas. Cézanne uses the theme for pictorial experimentation, leading him to develop a strong nonconformist style that always sought ways to interpret reality through painting. Thus, for Cézanne, painting from nature was important, because it enabled him to perceive a model in all of its separate planes.

Rocks in the Woods (1894–1898), oil on canvas, 23 × 19 in. Musée d'Orsay, Paris. Landscapes are one of Cézanne's favorite themes. He finds in nature all of the elements he needs for his work. He is not interested in portraying real color or a logical source of light. Rather, he is more interested in understanding and portraying, from an artist's point of view, reality in all of its facets, depicting all of the model's planes of reality. He often renders different versions of the same landscape, always giving a different solution to the same theme.

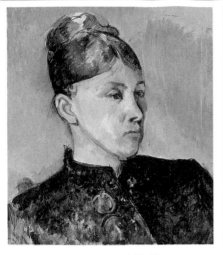

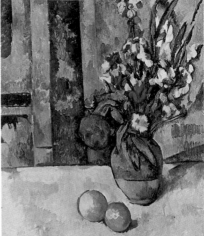

Portrait of Madame Cézanne *(1885), oil on canvas,
23 × 15 in. Philadelphia Museum of Art. The artist
breaks up the different planes of the model using
short, flat brushstrokes.*

Pitcher with Fruit and Flowers *(1883–1887),
oil on canvas, 22 × 18 in. Private collection, Paris.
Here one notes how forms are reduced
to simple geometric figures.*

In nature everything is structured in three fundamental shapes, the cube, the cylinder, and the sphere. One must first master these basic forms before drawing other subjects.

Large Bathers *(1898–1905), oil on canvas, 98 × 81.8 in. Philadelphia Museum of Art.
The large size of this painting forced the artist to paint inside his studio. However, the rich chromatic
hues he uses here attest to his many years of painting outdoors. For this last great work, he produced a large
number of sketches and thematic variations. The planes that define both the figures and the landscape are
shortened and juxtaposed within a triangular structure resembling a mountain.*

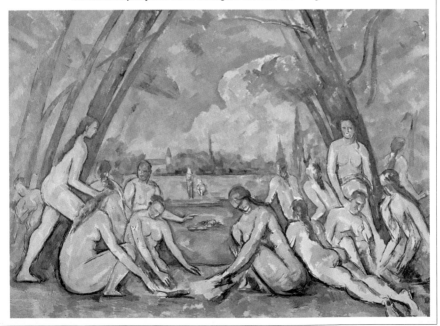

JOHN CONSTABLE

Like Turner, he is considered one of his country's best landscape artists.
He began to paint at an early age, but his artistic talent and originality developed slowly.
Though he never left England, Constable's work strongly influenced the landscape
painters of the Barbizon School and the later Impressionists. Ahead of his time,
Constable made his sketches outdoors but always finished his paintings in his studio.

*Self-portrait, oil on paper,
7.5 × 5.5 in. Private collection.
The Barbizon School adopted
Constable's outlook and open-air
approach to painting.*

Influences

• Was first influenced by his teacher, Benjamin West, as seen in the altarpiece of the Church at Brathem.
• Was also influenced by the English landscape artists of the seventeenth and eighteenth centuries.
• From Gainsborough and Girtin, he learned how to portray landscapes in Romantic fashion.

• Constable's work greatly influenced the Fontainbleau and Barbizon painters, as well as the Romantic painters in general.
• His work prompted Delacroix to modify his landscape in *The Massacre at Chios*.
• Established the principles of Impressionist painting.

Technical Characteristics

• Works are characterized by their green hues and by reflections of rain on trees; captures the hues of the British climatic environment.
• To achieve realistic atmospheric effects, he abandons the accepted traditional finish in his paintings and captures the play of light using delicate brushstrokes of pure or white color.
• Masters landscape drawing using smudges of color.
• Creates large spaces of sky.
• Obtains great depth of field using low horizons and elevated perspectives.
• Obtains different planes of depth by using opposing and simultaneous color contrasts.

LIFE OF THE ARTIST

1776—Born in East Bergholt, Suffolk, Great Britain; is raised at his father's estates in Dedham and Flatford.
1795—Makes frequent trips to London.
1799—Enrolls at the Royal Academy.
1802—Exhibits at the Salon of the Royal Academy.
1809—Is named academician at the Royal Academy.
1819—Named associate member of the Royal Academy.
1820—Begins to gain recognition; settles in Hampstead and then moves to Salisbury in Brighton, near the sea.
1821—His *Haywagon* (National Gallery, London) is well received at the Paris Salon.
1824—Wins a gold medal at the Paris Salon.
1828—His wife dies. Spends the rest of his life sad, lonely, and depressed.
1829—Is named a full member of the Royal Academy; his nontraditional depiction of nature and his Impressionist style are highly controversial.
1837—Dies in London.

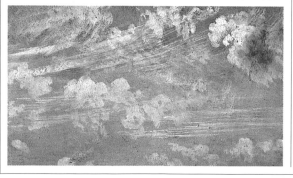

Study of Cirrus Clouds (1821), oil on paper, 7 × 4.5 in. Victoria and Albert Museum, London. Constable executed a large number of sketches outdoors. Though he did not paint on location, he liked to make his sketches from nature. His brushwork tries to capture the effects of light in a fresh and spontaneous manner.

The Cathedral of Salisbury Seen from the Episcopate Garden (1823), oil on board. Victoria and Albert Museum, London.
Weimouth Bay (1816), oil on board, 21 × 29 in. National Gallery, London.
Wheatfield (1826), oil on canvas. National Gallery, London.

• Avoids a casting effect by using free and decisive brushstrokes.
• Seeks the sublime and spectacular in his paintings, associating landscape and atmospheric effect with architectural monuments.

Themes

Constable was mainly a landscape artist; however, he also showed great technical genius as a portrait painter.

Parishioners in Stour with the Church at Dedham (1811), oil on board, 12 × 10 in. Victoria and Albert Museum, London. This painting synthesizes the traits of Constable's work that made him the model of both the Barbizon painters and the Impressionists. The landscape is rendered with scant, broad brushstrokes, with the paint showing visible signs of hard-rubbed brush marks. The forms are directly applied to the canvas, and pure white is used to obtain a brightness of color.

J' Constable

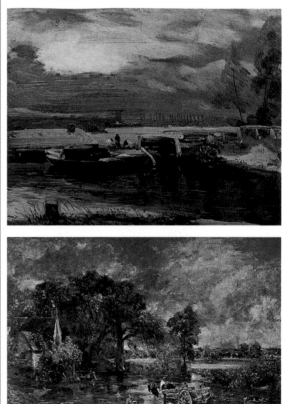

Sketch for the Sunken Carriage (1821), oil on board, 74 × 54 in. Victoria and Albert Museum, London. Constable's sketches are often entirely Impressionistic, with direct, intense brushstrokes and the effects of light giving life to the painting. The local colors that dominate are reflected in the surrounding objects.

Marina with Rain Clouds (1827), oil on paper, 12 × 8.7 in. Royal Academy of Arts, London. This superb landscape depicts an untamed and defiant nature scene. Done in a quick, nervous style, the artist uses the paintbrush to convey the effects of rain. The effects of light in the seascape are attenuated through small strokes of almost pure white, which blend with the gray of the background.

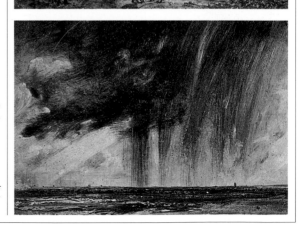

JEAN-BAPTISTE COROT

Known for his great humanity, Corot assisted Millet's widow and his friend Daumier financially, and even signed his name to the works of his lesser known painter friends. Though his works generally tend toward a Romantic style, he opposed Romantic and academic principles. Realist painters attacked his landscape paintings for their portrayal of mythological rather than real figures. Corot greatly influenced Impressionist landscape painters and his devotion to open-air painting became a main tenet of Impressionism.

Self-Portrait (1835).

Influences

• Was influenced by Ingres' classicism in his landscape and portrait paintings.
• Adopted the gaiety and intimacy of Vermeer in both his landscapes and female figures.
• Was influenced by Poussin's classical landscapes.
• Was inspired in his Romantic landscapes by Lorrain, Vermet, and Robert until 1859.
• From the early photographers Cuvelier and Grandguillaume, he acquired a realist vision of landscapes, giving them photographic qualities.
• Produced murals in collaboration with Millet.
• His paintings had a decisive influence on the works of many landscape artists who formed the link between the Fontainebleau painters and Impressionists.
• His murals at the Church of Ville d'Avray mark his transition between Romanticism and Impressionism.
• Influenced Cézanne's understanding of planes of light.

Technical Characteristics

• His landscapes are executed with fluid and direct brushstrokes.
• Alternates areas of light and shadow to create situational planes in the painting.
• Handles figures without excessive chiaroscuro, portraying luminous colors in the flesh tones.

Florence from the Gardens of Boboli (1835–1840), oil on canvas. Musée d'Orsay, Paris.

Self-Portrait at 29 Years of Age (1825), oil on canvas, 9.6 × 12.8 in. Musée d'Orsay, Paris.

The Bridge at Narni (1826), oil on canvas, 18.9 × 13.4 in.. Musée d'Orsay, Paris.

The Cathedral at Chartres (1830), oil on canvas, 20.3 × 25 in. Musée d'Orsay, Paris.

View Near Volterra (1838), oil on canvas, 7.1 × 5 in. Musée d'Orsay, Paris.

Portrait of Madame Baudot, oil on canvas, 15.8 × 12.6 in. Musée de la Ville, Semur.

Woman with Flower, oil on canvas. Galleria d'Arte Moderna, Milan.

The Eel Gatherers (1865), oil on canvas. National Gallery of Art, Washington.

Agostina (1866), oil on canvas, 38.4 × 52.2 in. National Gallery of Art, Washington.

Gypsy Girl with Mandolin (1874), oil on canvas, 29.5 × 31.5 in. Museo de Arte, Sao Paulo.

LIFE OF THE ARTIST

1796—Born in Paris.
1807–1812—Attends a boarding school in Rouen.
1815–1822—Works as a sales-clerk in a fabric store.
1822—Works at the studio of V. Bertin and learns to paint from nature.
1825—Produces a *Self-Portrait* displaying the features that will characterize the rest of his works.
1826–1828—Travels to Italy, studies portrait and landscape painting in depth.
1831–1833—Wins a medal at the Academy's Paris Salon.
1833—Travels to Soissons, where he meets Grandjean, who accompanies him on his second trip to Italy.
1839—Travels through France.
1840—Presents *The Little Shepherd Boy* to the Paris Salon. The state buys it for the Metz Museum. His reputation becomes more firmly established.
1846—Is officially commissioned to paint *The Baptism of Christ* for the church of Saint-Nicolas-du-Chardonnet.
1848—Nine of his paintings are accepted by the Salon.
1850—Works are well received by the critics and the public. Is supported by Baudelaire, Gautier, and Champfleury.
1855—Receives a medal at the Exposition Universelle for the work he presented.
1856—Executes four large murals for the church at Ville-d'Avray.
1858—Works on the banks of the Seine with the Impressionists, whom he has not yet met.
1862—Meets Courbet.
1875—Dies in Paris.

• Masters drawing through painting.
• Portrays carefully studied figures and perfectly defined forms against the background.

Themes

• Corot paints mostly landscapes in a Romantic style, though he executes them outdoors.
• Treats figures in an intimate way, depicting interior scenes full of calm and tranquillity.
• Shows a preference for women in his figure paintings.

COROT.

Gust of Wind *(1865–1870), oil on canvas, 23.2 × 18.7 in. Gallería d'Arte Moderna, Milan. An unusual theme in Corot's works. The rain and wind storms depicted in Romantic paintings were of little interest to the artist, though the painting here lies somewhere between Realism and Romanticism.*

The Baptism of Christ *(1847), oil on canvas, 81 × 15.7 in. Church of Saint-Nicolas-du-Chardonnet, Paris. This work was well received by the critics and was also praised by Delacroix. It faithfully reproduces the vegetation, climate, and even the light for that hour of the day. The in-depth study of the reflections in the pond would be adopted later by the Impressionists.*

Woman with a Pearl *(1868–1870), oil on canvas, 21.6 × 27.6 in. Musée d'Orsay, Paris. Corot, more of a landscape artist than a figure painter, based this painting on the same structure and study as Leonardo's Gioconda. In contrast, however, Corot's work is marked by a high degree of realism and, rather than a grandiloquent theme, depicts a humble subject enveloped by the same poetic aura that characterizes his landscapes.*

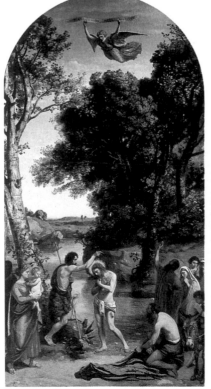

JEAN-DÉSIRÉ-GUSTAVE COURBET

Courbet's Realism developed as a reaction to the sentimentality of Romanticism and the rigidity of Neo-Classicism. Heir to the landscape painting of the Barbizon School, this movement adopted the Impressionist's approach to open-air painting. Courbet's social protests fostered in his followers a taste for scenes depicting simple people, thereby breaking with the historical tradition of the past.

Self-Portrait, Detail of
The Painter's Studio *(1855).*

Destruction of Vendôme Column.
Courbet was imprisoned and fined.

Influences

- Was a self-taught painter.
- Upon his arrival in Paris, took Géricault as a model.
- Was influenced by Caravaggio in his treatment of chiaroscuro.
- First works show a penchant for the classicism of Ingres and Delacroix.
- After seeing Rembrandt's work during a trip to Holland, he gained a new perspective on how to handle the effects of light, which became harsher and more realistic.
- Was encouraged by Boudin to paint seascapes on the coast of the English Channel.
- Courbet greatly influenced the Impressionists in their painting from nature and in their choice of subject matter, which favored social themes over bourgeois conventionality.

Technical Characteristics

- His early works are overly ambitious, with marked dra-

matic effects and forms defined through the use of chiaroscuro.
- After 1850 his works are ren-

Courbet with a Black Dog (1844), oil on canvas, 22 × 18 in. Musée du Petit Palais, Paris.
Dying Man (1844–1854), oil on canvas, 38 × 29 in. The Louvre, Paris.
Portrait of Juliette (1844), oil on canvas, 24.4 × 30.7 in. Musée du Petit Palais, Paris.
Lovers in the Field (1844), oil on canvas, 23.6 × 30.7 in. Musée de Beaux-Arts, Lyon.
Portrait of Baudelaire (1847), oil on canvas, 24 × 30 in. Musée Fabre, Montpellier.
Good Morning Mr. Courbet (1855). Musée Fabre, Montpellier.
Mme. Proudhon (1865), oil on canvas, 23.2 × 28.7 in. The Louvre, Paris.
The Seer (1865), oil on canvas, 15.3 × 18.5 in. Musée des Beaux-Arts, Besançon.

LIFE OF THE ARTIST

1819—Born in Ornans into a rural middle-class family.
1838—Frequents the workshop of Flajoulot, who is an apprentice of David.
1839—Travels to Paris to study painting.
1844—The Salon accepts one of his highly romantic works.
1847—Moves to Holland.
1848—Attends the social gatherings at the Andler pub, where Realist theories take shape.
1849—Receives a gold medal from the Salon and praise from Delacroix.
1850—Exhibits in Ornans and at the Salon highly realistic works that are well received by the critics.
1855—Moves to Montpellier.
1855—After rejection by the Salon, sets up an exhibition in a small wooden house, with a sign over the entrance that reads: *Realism. G. Courbet.*
1859—Meets Whistler and Boudin in Paris.
1859—Holds "the Great Realism Celebration" in his studio.
1861—Establishes a school; Fantin-Latour is among his students.
1864—*Venus and Psyche* is rejected by the Salon.
1867—His works are well received at the Salon.
1871—Launches the movement of the Commune; is elected to the town council and as a representative of Fine Arts; imprisoned and fined for destroying a monument to Napoleon.
1872—Flees to Switzerland penniless; is unable to pay his debt to the French authorities.
1873—Exiled in Switzerland.
1877—Dies of cirrhosis in La-Tour-de-Peilz, Switzerland.

The Hammock *(1844)*, oil, 38.2 × 27.6 in. Oskar Reinhat am Römerholz, Collection, Winterthur. In this work, Courbet delights in the natural simplicity of a young woman at rest, in a pose far removed from the conventional poses of mythological paintings. The figure is important to Courbet, and he executes it in a luminous manner. His use of a dark background and smooth lines sets the figure off from its surroundings.

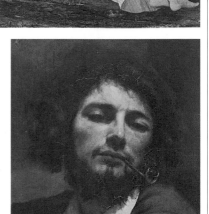

To be aware of and interpret the manners, ideas, and aspects of my own time—simply put, to portray vital art. This is my goal.

dered in a realist fashion with respect to his treatment of light and color, his detailing of all elements in the painting and in his perfect use of proportion and perspective.

Themes

• In his early career, he paints many self-portraits.
• The realism of Courbet's landscapes, which depict nature as it is without any theatricality, breaks with the Romantic ideal.
• Paints many highly symbolic hunting scenes, showing the drama of the dead animal.

Self-Portrait with a Pipe *(1848)*, oil on canvas, 14.6 × 17.7 in. Musée Fabre, Montpellier. Courbet mastered the art of portraits, which he rendered in every pose. Here one sees his perfect handling of chiaroscuro, with visible influences of Rembrandt; however, the informal, relaxed pose of the figure sets the self-portrait apart from academic painting.

The Burial of Ornans *(1849)*, oil on canvas, 261 × 123 in. The Louvre, Paris. Exhibited at the 1851 Salon, this painting was the object of much public criticism and ridicule at that time. The contrast between the reds and blacks accentuates the dramatic quality and forcefulness of the scene.

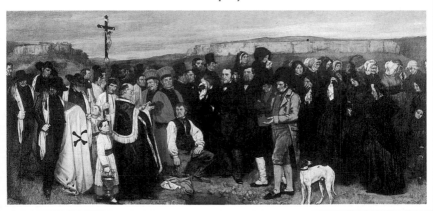

EDGAR DEGAS (I)

Degas was one of the greatest masters of sketching, painting, and sculpting of his time. His artistic formation was due to an in-depth schooling in the art of the ancient masters. His early works exhibit clear historical influences; however, after Monet introduces him to the Impressionists and particularly to Manet, Degas abandons historical themes in favor of contemporary ones, wherein he displays his tremendous dexterity in handling the effects of the light and in capturing the instantaneous. One of the most important Impressionist painters, he participated in seven of the eight exhibitions held by the group. Renoir believed that Degas was a greater sculptor than Rodin, and Pissarro considered him to be "the greatest artist of our time."

Self-Portrait,
pencil drawing (1852).

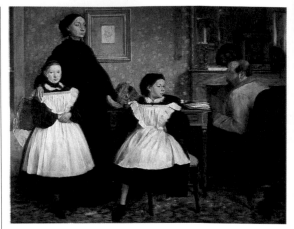

The Belelli Family *(1858–1860), oil on canvas, 98.5 × 79 in. Musée d'Orsay, Paris. Degas painted this portrait depicting his aunt, uncle, and nieces during one of his first trips to Italy. One notes in this work by the young Degas many of the traits that are found in his later works as well. It shows Degas' technical mastery of classical drawing and a chromatic synthesis that allows the artist to succinctly render the effects of light. The painting was among those found in Degas' studio after his death.*

Influences

• The classical masters Rafael, Mantegna, Ghirlandaio, Pollaiullo, and Botticelli were decisive influences in Degas' classical formation.

• From Ingres he learned the importance of the sketch when representing figures.

• Was introduced by Bracquemond to the work of Hokusai from whom he learned about the placement of images off-center and Oriental composition, and who inspired his interest in Japanese prints.

• Corresponded regularly with his father, who continually advised him on his artistic career.

• Zola's influence is seen in the naturalism of Degas' paintings that deal with social themes.

• He had a great influence on Toulouse-Lautrec, Bonnard, S. Valadon, and Vuillard.

• Influenced Toulouse-Lautrec through his sketches and paintings of the world of entertainment.

• His novel themes, such as the racetrack, greatly influenced his fellow Impressionists.

Technical Characteristics

• Paints in oils during his first period when he frequently attends ballet at the Opera.

• Before meeting the Impressionists, uses classical techniques in painting.

• Starts painting with pastels.

• Depicts expressively distorted bodies.

• Produces compositions with a decidedly Oriental character.

• Models ballet dancers, horses, and bathing women with great expressive force.

• Uses lines to construct form and emphasizes sketching over brushwork.

• Subtly displays chromatic harmonies between masses and color.

• Starts his compositions as tempera (*gouache*) or water-

LIFE OF THE ARTIST

1834—Born in Paris to a noble family.

1852—Completes high school and one year of law studies; coming from a wealthy family allows him to devote himself to painting.

1853—Studies in Barriás' studio; discovers Ingres.

1854—Studies in the studio of Louis Lamothe, an admirer of Ingres, and produces copies in the Cabinet des Dessins.

1855—Travels in Italy, where he discovers the great classical masters and the street shows, whose instantaneous motion intrigues him.

1859—Back in Paris, he begins to paint and to draw horses after being invited to the estate of several friends; meets Manet in the Louvre while copying Velázquez.

1868—Exhibits his portrait *Mademoiselle Fiocre at the Ballet La Source* at the Salon (1872–1878). Attends the Opera ballet on the rue Pelletier, where he develops his series of ballet dancers.

1874—His father's death leaves the family in a precarious economic situation.

1874—Sells the family collection to Durand-Ruel to settle his debts.

1874—Participates in the first Impressionist exhibition held at Nadar's studio and is the least criticized of the group.

1880—Organizes the fifth Impressionist exhibition.

1881—Alternates painting with modeling and casting.

1885—Meets Gauguin in Le Havre; paints only with flat tints; exhibits at the eighth and final Impressionist exhibition along with Pissarro, Odilon Redon, Schuffenecker, Seurat, and Signac.

1890—Travels to Spain; paints the only landscapes of his career.

1893—Has his first one-man show at Durand-Ruel's gallery.

1898—Nearly blind, he devotes himself almost entirely to sculpting.

1917—Dies after several years of self-imposed solitude.

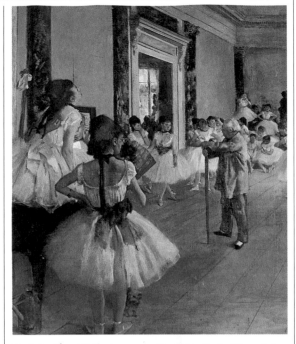

The Ballet Class *(1873), oil on canvas, 30 × 33.5 in. Musée d'Orsay, Paris. The Ballet of the Opera was one of the places Degas most often visited. He was very interested in dance and motion, as well as in the light of closed and interior spaces, an interest that Mary Cassat would adopt.*

colors, and finishes them with pastels.

• In his last pictorial stage, paints with flat tints that show a remarkable chromatic range of contrast between different masses and hardly any tonal variations of color.

• Emphasizes sketching through well-defined outlines, lines, or tracings throughout the painting.

Themes

From the beginning, Degas' most frequent themes are the portrait and the human figure, though he also produced many landscapes on his trip to Spain (1880).

• Throughout his career, Degas represented figures from different perspectives.

• Use of *Intimiste* themes: women bathing, combing their hair, etc.

Woman Ironing *(1869), oil on canvas, 24 × 29 in. Musée d'Orsay, Paris.*

The Painter Bonnat *(1863), oil on canvas, 14 × 17 in. Musée Bonnat, Bayona.*

Thérèse Morbilli de Gas *(1863), oil on canvas, 30.3 × 35 in. Musée d'Orsay, Paris.*

Opera Dance School *(1872), oil on canvas, 18 × 12.5 in. Musée d'Orsay, Paris.*

At the Horse Races: Before the Start *(1872–1873), oil on canvas, 13.3 × 10.2 in. National Gallery of Art, Washington.*

Dance Lesson *(1875), oil on canvas, 29.5 × 33.5 in. Musée d'Orsay, Paris.*

Friends of the Painter *(1879), pastel on cardboard, 22 × 31 in. Musée d'Orsay, Paris.*

At the Concert-Café *(1885), pastel, 11.4 × 10.2 in. Musée d'Orsay, Paris.*

EDGAR DEGAS (II)

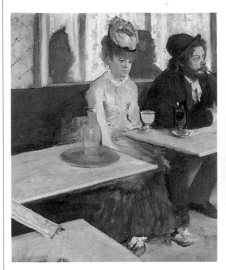

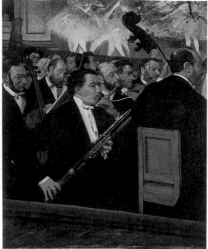

Absinthe *(1876), oil on canvas, 27 × 76 in. Musée d'Orsay, Paris. Scenes of bars and other common places represent a popular theme among the Impressionists. Images such as the one shown here provide a clear understanding of the main traits not only of Degas' work but of Impressionism and Postimpressionism in general. Placing figures off-center is a direct inspiration from Japanese prints. So, too, is the use of unusual composition that, in this case, places the table between the figures and the viewer. The scene is also reminiscent of a snapshot depicting two total strangers who are completely absorbed in their own thoughts and drinks. The decadent theme inside a common tavern represents a break from tradition and a motif that Toulouse-Lautrec would later frequently use.*

The Opera Orchestra *(1868), oil on canvas, 18 × 22.3 in. Musée d'Orsay, Paris. Capturing the immediacy of the moment is highly important in Degas' work. This scene portrays a moment at the opera in which the musicians are tuning their instruments and, in the background, the ballet dancers are warming up for the performance. It is interesting to note how Degas handles characters and planes through a detailed work of light.*

It is fine to copy what one sees, but much better to represent what one has stored in memory. This involves a transformation in which imagination and memory come into play at the same time. Only what has made an impression should be portrayed; that is, only what is necessary. In this way memories and fantasy are able to free themselves from the tyranny of nature.

• Dancers: objective and real-istic scenes of one or more ballet dancers that capture a fleeting moment of their professional life.

• Scenes depicting the world of entertainment, especially cabaret figures.

• Horse race themes: masters the anatomy and postures of the horse as well as the atmosphere and environment of horse races.

Studies of a Café Singer Singing *(1878), pastel and charcoal on gray paper. Private collection, Philadelphia.*

Woman's Head *(1867), oil on canvas, 8.7 × 10.5 in. Musée d'Orsay, Paris. Degas always sought subtlety between color and form. He specialized in figure and portrait painting. Translucent flesh tones and carefully rendered facial features alternate with the quasi-photographic focus on the face's salient points. All other elements not forming part of the painting's central focus are sketchily drawn.*

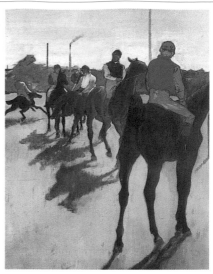

Jockeys before the Grandstand *(detail) (1869–1872), turpentine oil on canvas, 25.5 × 21.5 in. Musée d'Orsay, Paris. Degas was an assiduous visitor of race tracks. His mastery in capturing fugitive moments has never been equaled. Japanese prints place elements in the foreground of the central motif and break with traditional perspectives by reducing the size of the elements and avoiding rigid outlines. These same features can be observed in this work.*

In the Concert-Café, the Ambassadors *(1877), pastel, 10.5 × 14.5 in. Musée des Beaux Arts, Lyon. Light captured in night settings is one of the most typical elements in Degas' work. Simultaneous contrasts clearly highlight the different planes and the sharp contours of the figures, providing directional focus.*

Dancers in the Wings *(1890), oil on canvas, 29.5 × 33.5 in. Musée d'Orsay, Paris. Degas is one of the greatest pastel artists in history. Using pure unmixed colors, he creates the impression that colors blend in the viewer's eye, rather than on the canvas. He uses oils in the same way, such as in this painting where he applies direct patches on a perfectly drawn base and plays with a dense and opaque chromaticism.*

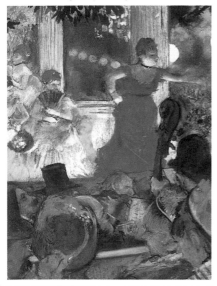

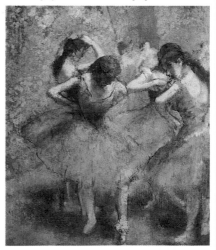

THE ARTISTS

HENRI FANTIN-LATOUR

With close ties to the Impressionist group, Fantin-Latour was, for a while, influenced by them. At the same time, however, he always managed to distance himself somewhat from the group, preferring studio work to open-air painting. Fantin-Latour is most famous for his portraits of his Impressionist friends, and he was the final link between Romantic and Impressionist painting.

Self-Portrait, *charcoal drawing.*

LIFE OF THE ARTIST

1836—Born in Grenoble, the son of the painter Théodore Fantin-Latour, who first introduces him to painting.
1850–1854—Studies with Lecocq de Boisbaudran.
1855—Studies Fine Arts.
1860—Enters Courbet's studio.
1860—Meets Berthe Morisot and then introduces her to Manet.
1861—Exhibits at the Salon.
1863—Begins to exhibit regularly at the Salon des Refusés.
1904—Dies in Buré, Normandy.

Influences

• Was a great friend and admirer of Delacroix, who influenced his early works.
• Also influenced by Corot throughout his career, especially in his interior scenes with flowers.
• From Courbet, he acquired a taste for realism and an interest in painting outdoors.
• The paintings of Manet and Whistler, with their treatment of the effects of light, had a significant impact on his works.
• His group portraits reflect German influences.

Technical Characteristics

• Fantin-Latour masters to perfection all the plastic (three-dimensional) techniques, and is highly skilled in each, always within classical confines.
• His treatment of light, an area of great interest to his Impressionist friends, is highly intuitive.
• His mastery of color helps him to define sky spaces with great clarity.
• With free and decisive brushwork, makes use of a variety of techniques, such as dry point, impastos, or castings.

Self-Portrait *(1861), oil on canvas, 26 × 32 in. E.G. Bührle Collection, Zurich. From 1853 to 1861 Fantin-Latour paints mainly self-portraits, painting some thirty works during this time. The self-portrait here shows Rembrandt's influence. Fantin-Latour's chiaroscuro is highly dynamic and realistic at the same time. The work is executed with an easy style, the facial forms being expressed by the light shining on them.*

• Usually mixes colors on the palette, but sometimes uses pure color, especially to highlight bright or highly luminous areas.
• Alternates large highly shaded areas with detailed shapes, using small brushstrokes.

Themes

• Paints a wide range of themes including interior scenes, especially paintings depicting flowers and groups of people.
• The flower paintings display an almost photographic realism and a keen rendering of mood and relationship between adjacent colors.
• His portraits show a realistic touch in the psychological analysis of the person. Fantin-Latour captures his subject's personality through a characteristic gesture, look, or pose.

Bouquet of White Roses with Peaches *(1873), oil on board, 21.5 × 22 in. E.G. Bührle Collection, Zurich. In addition to his self-portraits, Fantin-Latour also displays a great talent for painting other portraits as well as still lifes with flowers. The luminous glow of the roses is intensified by a dark background; the peaches are perfectly drawn with precise brushstrokes.*

Fruits and Flowers *(1865) oil, 22.5 × 25 in., Musée d'Orsay, Paris. A follower of Realism, Fantin-Latour studied the classics in depth, as well as Rembrandt's and Velázquez's theories on light. His use of pure colors within a controlled texture was of great interest to the Impressionists.*

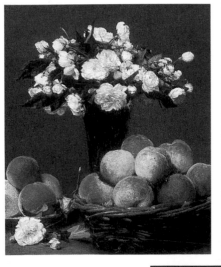

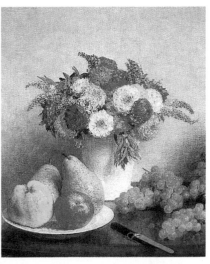

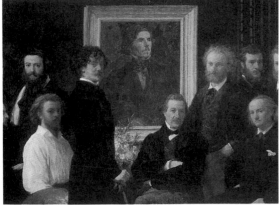

Homage to Delacroix *(1864), oil on canvas, 98.5 × 63 in. Musée d'Orsay, Paris. One of Fantin-Latour's best works, this painting was exhibited at the 1864 Salon. The artist, in shirtsleeves, is included in the painting along with his friends Whistler, Manet (standing to the right), and Baudelaire, seated to the right. Everyone is gathered around a portrait of Delacroix.*

PAUL GAUGUIN (I)

Together with Cézanne and van Gogh, Gauguin is one of the greatest exponents of Postimpressionism. Painting was a hobby for him until he met Pissarro. Although he painted for a time in the Impressionist style, his contribution to art came about after he distanced himself completely from the group, developed his own style, and founded a school. Gauguin gave rise to Synthesism, which culminated in Fauvism and the Nabis.

Influences

• Gauguin was first influenced by the Impressionist group.
• The works of Pissarro, Manet, Renoir, and Degas awakened his artistic sensibilities.
• Through Oriental art, particularly Japanese prints, he acquired an interest in pictorial space as depth conveyed through situational planes rather than tonal variations.
• His contact with Cézanne gave him an understanding of rendering volume in painting by disassociating a series of planes executed through flat tints.
• His relationship with van Gogh, which contributed to and heightened his creative restlessness, made him aware of the symbolism of color.

Paul Gauguin.

• From Seurat's divisionist theories (Pointillism) he gained an understanding of the optical effects of color.
• With Bernard, he developed the so-called Synthesism.

Gauguin's Influences on Later Painters:
• Influenced the Fauvists and the Nabis in their interpretation of colors as planes rather than tonal gradations denoting shape.
• Gauguin influenced the entire avant-garde movement of the twentieth century up to Pop Art.

Technical Characteristics

• Uses pure color.
• Ties together different planes through pure color, combining the brushwork within the same plane.
• Applies colors in smudges without tonal gradations.
• Beginning with Synthesism or Cloisonism, planes are separated from each other by dark lines that outline the contours of the shapes within the painting.
• The painting's planes are explicitly separated. The foreground is clearly detached from the background planes.
• Renders contrasts by using complementary colors.
• Gives up a naturalistic treatment of color, being more interested in its symbolism than real value.
• Breaks with the traditional treatment of perspective, preferring the Oriental style for portraying space and depth.
• Uses shadows or objects to enhance the composition of the painting, disregarding the realistic rendition of the theme.

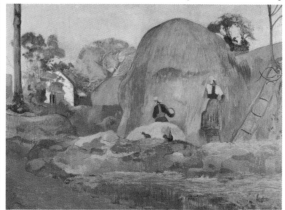

The Golden Harvest (1889), oil on canvas, 36 × 28 in. Musée d'Orsay, Paris. The colored planes in the landscape are completely defined by zones.

LIFE OF THE ARTIST

1848—Born in Paris to an American journalist father and a Peruvian mother.

1872—Works as a highly successful stockbroker.

1874—Meets Pissarro and visits the first Impressionist exhibition; is attracted to Impressionist painting and begins collecting paintings by the group.

1876—Exhibits with the Impressionists from the fifth to the eighth exhibition.

1886—Leaves his job to devote himself to painting; financial difficulties force him to sell his collection of paintings below market price; abandons his family and goes to Pont-Aven, an artistic center.

1887—Travels to Panama and Martinique; in the work he produces there, contours tend to disappear and his colors approximate flat tints.

1888—Paints his first work in a non-Impressionist style: *The Vision after the Sermon, Jacob Fighting with the Angel*; in his second period in Pont-Aven he develops, together with Émile Bernard, the technique of Synthesism or Alveolism, the separation of forms through dark lines.

1889—Spends a short time with van Gogh in Arles, but the relationship ends badly.

1891—Leaves France for Tahiti, where he writes *Noa Noa*.

1893—Misery and poverty force him to return to France.

1895—Inheritance from an uncle allows him to return to Tahiti.

1897—Paints his most important work: *The Allegory of Life: What are We? Where Are We Going?* His favorite daughter dies.

1898—Is forced to sell his paintings to Vollard.

1900—Signs a contract with Vollard; agrees to turn over all new paintings to him.

1901—Sick, he moves to the island of Hiva Hoa where he lives with the Maori people.

1903—Poverty stricken, dies from syphilis in Atuana, Marquesas Islands.

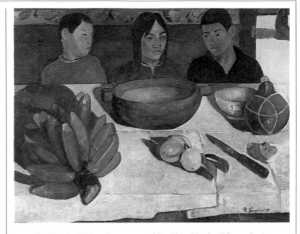

The Meal *(1891), oil on canvas, 36 × 28 in. Musée d'Orsay, Paris. One of the first works Gauguin painted in Tahiti. The children occupy the top plane, while the bottom part of the painting, strictly divided horizontally, shows a still life.*

Themes

• Gauguin deals with a wide range of themes, limiting himself to a specific theme only if delving into a study of the subject.

• His colorful landscapes consist of well-differentiated planes, and he even constructs planes of complementary colors.

• Paints many still lifes. These themes serve as experimental stages in his pictorial evolution.

• Portrays figures either by integrating them in the landscape or by treating the figure as a central theme. In these themes, his interest in the exoticism of Tahitian women is particularly evident.

Mandolin and Flowers (1855), oil on canvas, 25 × 21 in. Musée d'Orsay.

The Seine with the Jena Bridge (1875), oil on canvas, 25.5 × 36 in. Musée d'Orsay.

Tropical Vegetation (1887), oil on canvas, 45.5 × 35 in. National Gallery of Scotland, Edinburgh.

The Washerwomen of Arles (1888), oil on canvas, 29 × 36 in. Museo de Bellas Artes, Bilbao.

The Maidens of Arles (1888), oil on canvas, 29 × 36 in. Art Institute of Chicago.

The Vision after the Sermon (1888), oil on canvas, 29 × 36 in. National Gallery of Scotland, Edinburgh.

The Wooden Grille (1889), oil on canvas, 36 × 29 in. Private Collection, Zurich.

Beach at Pouldu (1889), oil on canvas, 29 × 36 in. Private Collection, Detroit.

The Man with the Ax (1891), oil on canvas, 36 × 27.5 in. Private Collection, New York.

Nafea faa ipoipo (When Do You Marry?) (1892), oil on canvas, 41 × 30 in. Kunstmuseum, Basilea.

Pape Moe (The Mysterious Water) (1893), oil on canvas. Private Collection, Zurich.

PAUL GAUGUIN (II)

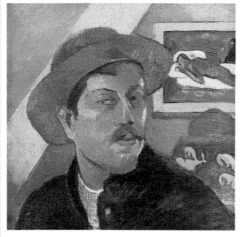

Self-Portrait with a Hat *(fragment), oil on canvas, Musée d'Orsay, Paris. In this work we note latent influences by Cézanne: straight and shortened planes, a radical gradation of tones, and alternation of overlapping planes with planes of pure color. One can already anticipate Gauguin's style, which places great importance on the synthesis of forms with precisely drawn contours that separate them from each other.*

The Pretty Angel *(1889), oil on canvas, Musée d'Orsay, Paris. Following his trip to Martinique, Gauguin painted several portraits of Breton women, the most outstanding of which is the one shown here. One sees in this work a mixture of Cloisinism, Symbolism, and influences from Japanese painting.*

El Aven in Pont-Aven *(1888), oil on canvas, 36.5 × 28 in. Private collection, Berne. The planes in this landscape are executed with short, precise brushstrokes that form clear color masses separated by complementary tones.*

Tahitian Women on the Beach *(1891), oil on canvas, 36 × 27 in. Musée d'Orsay, Paris. Gauguin tried his best to become a Maori and to integrate with them, to live as if he were a native Tahitian, and to understand their customs. He constantly painted their women. He tried, through his many female companions, to leave his legacy by fathering children with them. This not only caused him many emotional problems, but was also seriously detrimental to his health. The painting portrays a scene of the lazy Maori life. It is a studied composition in which the artist uses flat, brilliant colors.*

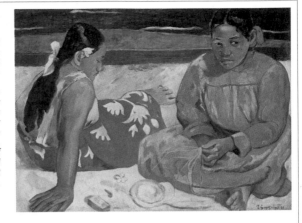

What does this tree look like to you? Does it look green? Then paint it green, with the most beautiful green on your palette. And this shadow, does it look blue? Then don't for a second hesitate to paint it the bluest color possible.

Two Tahitian Women *(1899), oil on canvas, 29 × 37 in. Metropolitan Museum of Art, New York. Light becomes pure color, with almost flat tints. The lines that define the forms are plainly visible in the figures. During his entire stay in Tahiti, Gauguin tried to integrate with the inhabitants of the island, but his financial difficulties forced him to return to France. Upon his return to Tahiti, the Maoris showed him love and admiration. In fact, in Maori culture, craftsmen and artists are thought of as having a divine gift. Because of a scarcity of painting materials in Tahiti, most of Gauguin's work there was done with a thin paint that, at times, lacked oil. This allowed the artist to show very fine layers of color. Lack of material was a decisive factor in the superior quality and production of his work. It also prompted Gauguin to have different plastic experiences such as carving or wood engraving.*

The Yellow Christ *(1889), oil on canvas, 29 × 36 in. Albright Art Gallery, Buffalo. In this painting, lines predominate over form. Here Gauguin uses totally unreal, symbolic colors. The foreground is the dominant plane. The bisected figures give the painting an almost photographic quality.*

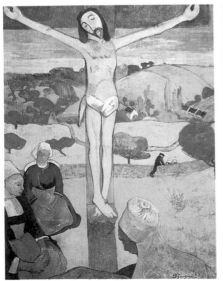

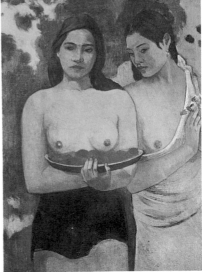

VINCENT WILLEM VAN GOGH (I)

One of the most controversial artists in history, van Gogh's mark on the art world is such that, had it not been for him, several of today's artistic movements would not exist. A Postimpressionist who took on the group's aesthetic application of color, his work demonstrates how reality can be captured through introspection. Noted for their bold colors and brushwork, expressed in form and chromaticism, van Gogh's works mark the first step toward what would later evolve into Expressionism.

Self-Portrait *(1889),*
oil on canvas, 18 × 25.5 in.
Musée d'Orsay, Paris.

Influences

• Van Gogh's early works were influenced by Millet in their social realism and tendency to portray workers and peasant life.

• His work shows a surprising change after he moves to Paris and meets the Impressionist group. Early influences came from Pissarro, Degas, Gauguin, and Toulouse-Lautrec.

• He painted with a violent brush; adopted Seurat's style of constructing forms by placing tones close to one another using loose brushstrokes. Later in his career, his brushstrokes became longer and he began to model sketchlike forms.

• Was inspired by Japanese prints and engravings in their conception of space and their break from Western norms of perspective.

An Italian Woman *(1887), oil on canvas, 23.5 × 32 in. Musée d'Orsay, Paris. A key feature of van Gogh's technique is his free use of brushstrokes and color. His painting is highly mannered and characterized by the simultaneous use of complementary colors. The great force of his brushwork is enhanced by his lively treatment of color. Here he abandons his search for natural color in favor of a pure coloring, a feature that will have a decisive influence on Fauvist and Expressionist painters.*

L'Arlésienne (Madame Giroux) *(1888), oil on canvas, Musée d'Orsay, Paris. Among van Gogh's favorite themes are his portrayals of peasants and his portraits of friends and acquaintances. During his stay in Arles, he did several portraits of his neighbors, showing powerful contrasts. The simultaneous contrasts here between the figure and the background strongly highlight the main forms in the painting.*

LIFE OF THE ARTIST

1853—Born in Groot Zundert, Netherlands.

1872—Begins to write to his brother Théo, who supports him throughout his life.

1873—Moves to London to a branch of the Goupil gallery.

1876—Because of his temperament, is dismissed from the gallery and becomes consumed by religious fervor and Bible study, studies theology at the university, but leaves after one year to live in Etten with his father.

1878—Moves to Brussels and tries to become a preacher, but is not recognized by the Committee of Evangelization, does missionary work in the mining region of Borinage. In Wasmes, devotes himself to humanitarian and religious work and lives miserably in a hut. His way of life prompts the community of Wasmes to relieve him of his duties. Feeling rejected by society, he becomes interested in the work of Victor Hugo, Charles Dickens, and Emile Zola. Does his first sketches of the mines.

1880—In Etten, becomes interested in drawing and studies perspective and anatomy. Copies Millet's work.

1881—Paints portraits and landscapes from nature with his friend Van Rappard.

1883—Produces a significant number of works: open-air landscapes and portraits; through his brother Théo, becomes acquainted with the work of the Impressionists and is influenced by their style.

1887—First exhibition with Gauguin, Toulouse-Lautrec, and Emile Bernard.

1888—Lives with Gauguin in Arles, but they quarrel and separate shortly after.

1889—Is frequently hospitalized for emotional crises.

1890—Commits suicide with a gun in Auvers-sur-Oise, Ile-de-France.

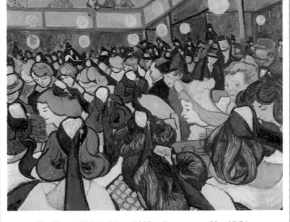

The Dance Hall in Arles *(1888), oil on canvas, 32 × 25.5 in. Musée d'Orsay, Paris. Influences from Gauguin and Toulouse-Lautrec are evident in this work. The festive and boisterous theme is expressed through planes of color without tonal volume. The flat tints define specific areas and outline perfect contours.*

Vincent

• Eliminated any type of social messages from his paintings. Following the period in which he is influenced by Millet's social moralism, van Gogh's social themes became a background element, used more as a thematic excuse than as a means to a moral end.

Van Gogh's Influence on Later Generations of Artists:

• Precursor of the Expressionist movements that evolved throughout the twentieth century.

• Introduced optical realism, developed Seurat's theories unscientifically.

• Painted in an almost abstract manner; his rendition of forms and color caused a great stir in Fauvism and Expressionism.

Church in Neumen (1884), oil on canvas, 25.5 × 21 in. Rijksmuseum Vincent van Gogh, Amsterdam.

Houses in Ambères (1885), oil on canvas, 17 × 13 in. Rijksmuseum Vincent van Gogh, Amsterdam.

The Restaurant in Sirène (1887), oil on canvas, 27 × 22.5 in. Musée d'Orsay, Paris.

Self-Portrait in Front of an Easel (1888), oil on canvas, 20 × 25.5 in. Rijksmuseum Vincent van Gogh, Amsterdam.

La Musmé (1888), oil on canvas, 24.5 × 20.5 in. National Gallery of Art, Washington.

Hallway in the Hospital of Arles (1888), oil on canvas, 29 × 36 in. Sammlung Oskar Reinhart, Winterthur.

Student Figure (1890), oil on canvas, 21 × 25 in. Museo de Arte, Sao Paolo.

Starry Night (1889), oil on canvas, 36 × 29 in. Museum of Modern Art, New York.

Doctor Gachet's Garden (1890), oil on canvas, 29 × 20 in. Musée d'Orsay, Paris.

VINCENT WILLEM VAN GOGH (II)

Portrait of Joseph Roulin *(detail), oil on canvas, Museum of Fine Arts, Boston. Bitter, animated colors characterize all of van Gogh's paintings. Though he treats his models with high regard and respect, his portraits are, for the most part, experimental exercises with regard to shapes and palette work.*

Portrait of Armand Roulin *(detail), oil on canvas, Museum of Fine Arts, Boston. Here one sees another fine portrait by van Gogh. He painted the Roulins within a short time of each other. His direct drawing allowed him to study the man as he painted him and to alter and correct the canvas while the paint was still wet.*

most important element, his paintings develop a language of their own.
• Different areas in the paintings are delineated by both brushstrokes and chromatic ranges.
• The distorted figures and objects provide a rhythmical element to his work, which is echoed in the whole painting.
• Complex compositional structures, with no empty spaces.

Themes

Van Gogh treats a wide range of themes.
• His early works are characterized by their social themes, as evidenced by figures such as miners, textile workers, and farmers, and by interior scenes portraying peasants.
• Landscapes are also one of van Gogh's favorite subjects. In these he attempts to capture the entire range of colors reflected in his models, always painting them outdoors.
• He paints still lifes in all of his artistic periods, experimenting with pictorial principles that he would later apply to the rest of his paintings.
• One of his most important pictorial contributions comes from his portraits.

Technical Characteristics

• Optical alteration of the colors in the painting.
• Use of pure colors.
• Contrasts created by using complementary colors.
• Use of free and direct brushstrokes.
• Absence of tonal fusion.
• Importance given to drawings in all his paintings.

• Sketchily contoured figures.
• Modeling of figures using directional brushstrokes to create optical lines.
• As he grows increasingly sicker, his colors get brighter and more vivid. Brushstrokes become increasingly more rapid, and forms are modeled with gestural lines rather than tonal variations.
• Though drawings are their

The Potato Eaters *(1885), oil on canvas, 45 × 32 in. Rijksmuseum Vincent van Gogh, Amsterdam. Van Gogh discussed this painting in a letter to his brother Théo, describing his love for peasants and their noble hands that work the soil. This painting represents one of van Gogh's most important works dealing with a social theme and displays a highly expressive gestural form of painting.*

Van Gogh's Room at Arles *(1888)*, *oil on canvas, 35.5 × 28 in. Rijksmuseum Vincent van Gogh, Amsterdam. In one of his letters to Théo, van Gogh describes and draws this painting. Two other copies are at the Musée d'Orsay. The painting displays powerful contrasts and a lively chromaticism, strong directional brushstroke and an almost claustrophobic perspective. The whole of the painting is imbued with a sense of vitality.*

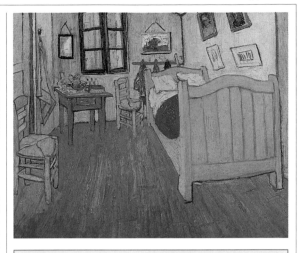

• Van Gogh's portraits are the result of a deep psychological study of his models. His portraits were often painted in return for a favor or to pay off a debt.

Don't believe that I can contain my creative fever. I train myself to carefully calculate everything I do. Though I paint one canvas after another very quickly, I have given careful thought to each one of them beforehand. To those who say that my paintings have been executed too quickly, I say it is you who has looked at them too fast.

Portrait of "Father" Tanguy *(1887), oil on canvas, 29.5 × 36 in. Rodin Museum, Paris. This man, who owned a small art supply business, often provided materials to painters who couldn't afford to pay for them. Van Gogh did this portrait of him as a form of payment and gratitude. Behind the subject one notes evidence of van Gogh's interest in Japanese prints. The chromatic expressiveness and the features of the subject make this one of the artist's best portraits.*

The Church at Auvers *(1890), oil on canvas, 29 × 37 in. Musée d'Orsay, Paris. Van Gogh's gestural brushstrokes evolved into what would become Expressionism. The sky, land, and other objects are distorted. The seeming symmetry of the painting is slightly off-center, creating a highly interesting arrhythmic composition.*

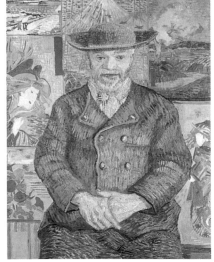

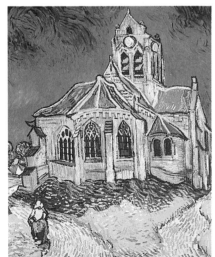

ÉDOUARD MANET (I)

A member of the upper middle class, Manet never had financial worries and did not depend on the sale of his paintings for income. Though a leader of the Impressionist revolt, he always aspired to be accepted by the academic circles. His works were not understood by the traditional art establishment of his time and he spent his whole life desiring a place of honor in the official art world. The unwilling leader of the Impressionist group, Manet sympathized with their ideas and especially enjoyed the company of Degas.

Édouard Manet.

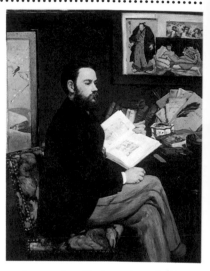

Portrait of Zola (1868), oil on canvas. Zola's support stands out among the intellectual influences on Manet.

Influences

• Learned to paint from Thomas Couture, though the two didn't share similar ideas on painting.
• Was strongly influenced by traditional painting.
• Unlike Couture, Manet used common people, itinerant artists, and jugglers as his models.
• Was inspired, at least for a time, by Spanish painting, especially in his highly gestural brushstrokes and dynamic lines.
• Studied the works of old masters such as Titian, Rembrandt, and Velázquez, which enriched his artistic formation and renderings of figures and backgrounds.
• Adopted from the modern masters Goya, Delacroix, Courbet, and Daumier a technique of fluid brushwork and dynamic expression of forms.
• Was encouraged to paint outdoors by other Impressionists, including his sister-in-law Berthe Morisot.
• Although never claiming to

be part of the group, he was considered by the Impressionists to be their leader and he unwillingly served as the head of the movement.
• Despite never wishing to be an active member of the Impressionist group, his work became increasingly more Impressionistic, likely a result of influences from Pissarro and Monet.

Technical Characteristics

• Abandons historical and grandiloquent themes.
• Eliminates chiaroscuro and the transitional tones of modeling from his work.
• Challenges the viewer in his paintings.

• Displays dynamic brushwork emphasizing light and color, the result of his ties with the Impressionists.
• Chooses a technique appropriate for the theme and character of a work. When attempting to capture a first impression, he always uses free, spontaneous brushstrokes. In his more structured works, he uses elaborate color planes.
• Takes great care in using free, vibrant brushstrokes to portray the reflections of light on water. Avoids the blending of superimposed colors.
• Uses many different pictorial techniques throughout his career.

Themes

• Uses a wide variety of themes throughout his career.

LIFE OF THE ARTIST

1832—Born in Paris, his father was head of personnel at the Ministry of Justice and his mother was the daughter of a diplomat.

1845—Follows the advice of his uncle Edmond-Eduardo Fornier and enrolls in a drawing class where he meets Antonin Proust, future minister of Fine Arts.

1849—Returns from a trip to America with a large number of drawings.

1850—Frequents Coutour's studio.

1853–1856—Travels throughout Italy, Germany, and Holland, copying the old masters.

1856—Leaves Coutour's studio; meets Fantin-Latour at the Louvre and copies Delacroix's work *Dante and Virgil in Hell.*

1859—His work, *The Absinthe Drinker,* is rejected by the Paris Salon.

1862—Meets Victorina Meurent, the model for his *Olympia.*

1863—Marries the pianist Susana Leenhorf.

1863—The Salon des Refusés considers him the precursor of antiacademicism.

1865—Presentation of Olympia, a work based on *Venus of Urbino.*

1867—Tired of being excluded from the Salon and from official events, he decides to organize a private exhibition.

1871—Political turmoil prompts him to leave Paris and settle at Oloron-Sainte-Marie.

1871—The dealer Durand-Ruel buys several of his paintings.

1874—Paints with Renoir and Monet.

1876—Organizes a private exhibition in his studio under the banner "Do what is right and let them have their say."

1881—Receives an award from the Legion of Honor.

1883—Has a gangrenous leg amputated. Dies in Paris.

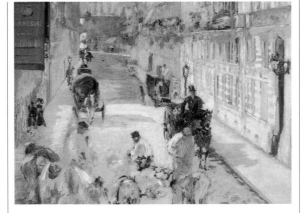

Mosnier Street with Stone Cobblers, *oil on canvas. Private collection. An urban landscape rendered with a highly expressive synthesis of brushstrokes and color. Manet shows a talent for capturing the moment that only Pissarro comes close to matching; his brushstrokes are applied with a single stroke.*

His search for novel themes, such as the horse race, tavern, and photographic scenes, was one of the reasons he became the head of the Impressionist movement. Another was his continuous study of the effects of light on objects, which led him to render figures using almost flat colors rather than traditional tones in modeling.

• His portrait and figure paintings display his concern for painting reality as it is, providing a realistic rendering of the effects of light on the model.

• His landscapes are characterized by a high degree of expressiveness and freedom, revealing careful studies of light and sky in each of the paintings' different planes. These works treat a wide variety of rural and urban themes, with the latter showing great spontaneity and synthesis.

Mademoiselle Victorine in the Costume of an Espada (1862), oil on canvas, 51 × 65 in. Metropolitan Museum of Art, New York.

Lola of Valencia (1862), oil on canvas, 48.5 × 36 in. Musée d'Orsay, Paris.

Still Life with Fish and Oysters (1874), oil on canvas, 36 × 29 in. Art Institute of Chicago.

The Bullfight (1865–1866), oil on canvas, 24 × 19 in. Art Institute of Chicago.

Woman with a Parrot (1866), oil on canvas, 52 × 65 in. Metropolitan Museum of Art, New York.

Portrait of Théodore Duret (1868), oil on canvas, 14 × 17 in. Musée du Petit Palais, Paris.

The Balcony (1868), oil on canvas, 49 × 67 in. Musée d'Orsay, Paris.

Profile of Manet's Wife near the Piano (1868), oil on canvas, 18 × 15 in. Musée d'Orsay, Paris.

Portrait of Stéfane Mallarmé (1873), oil on canvas, 14 × 11 in. Musée d'Orsay, Paris.

Argenteuil (1874), oil on canvas, 51.5 × 58.5 in. Musée des Beaux-Arts, Tournai.

Red Head with a Low-Cut Dress (1878), oil on canvas, 20 × 24.5 in. Musée d'Orsay, Paris.

Waitress with Pitchers in a Tavern (1878–1879), oil on canvas, 31 × 38.5 in. National Gallery, London.

House in Reuil (1882), oil on canvas, 36 × 29 in. Victoria National Gallery, Melbourne.

ÉDOUARD MANET (II)

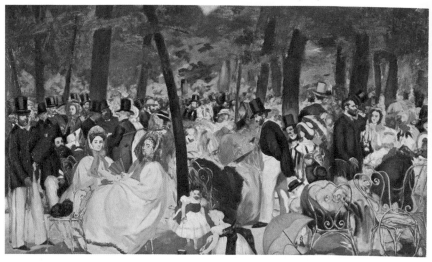

Music in the Tuileries *(1862), oil on canvas, 47 × 30 in. National Gallery, London.*
Manet's influence is seen in all Impressionist themes and in the Impressionists' handling of figures in secondary planes. Monet and Renoir especially used this theme in their works. Manet's handling of figures is important. He uses short, direct brushstrokes, rendering forms in a very schematic manner.

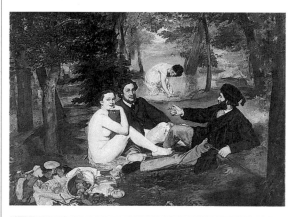

Luncheon on the Grass *(1863), oil on canvas, 104 × 82 in. Musée d'Orsay, Paris. One of the great paintings that led to debate and scandal. Lack of understanding by the public and the critics turned Manet into the standard bearer of antiacademicism. His handling of the theme, a nude woman between two men who is challenging the viewer with her defiant stare, breaks totally with the academic and historical tradition of official painting. The treatment of color also forebodes a total disregard for traditional forms in painting.*

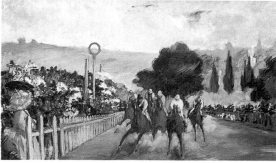

Races at Longchamps *(1864), 33 × 17 in. Art Institute of Chicago. Until the invention of photography, horses racing was depicted with all four of the horse's feet off the ground. Manet goes beyond the snapshot and conveys what the eye captures fleetingly, the dynamism and fervor of the horse race. For this he uses lively and nervous brushstrokes, synthesizing, with the least amount of effort possible, all of the vigor the scene conveys.*

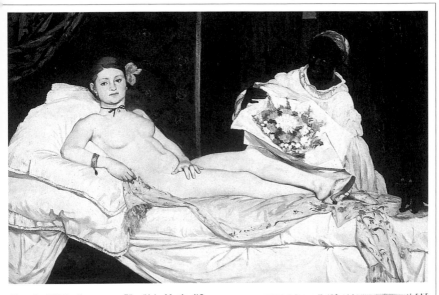

Olympia *(1863), oil on canvas, 75 × 51 in. Musée d'Orsay, Paris. Exhibited in 1865. One of Manet's most polemic works. The public and the critics at the time were unaccustomed to viewing a nude outside the established norms prescribed by historical painting. The Olympia nude is realistic, defiant, and provocative with her stare. The colors in the painting provide tonalities of light that suppress the need for modeling and chiaroscuro.*

Daumier, Satirical criticism of Manet's *Olympia. In front of Manet's painting: "Why the devil is this red woman in a shirt called Olympia?" "My friend, maybe it's the name of the black cat."*

I couldn't express anything without Nature. I don't know how to invent. I've tried, at times, to paint from what I've learned, but the results were not worth the effort. Any merit I might have earned I owe to my exact interpretations and faithful analyses.

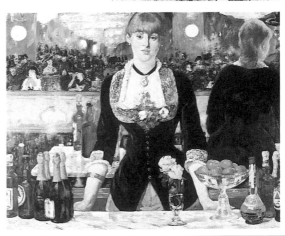

The Bar at the Folies Bergère *(1881), oil on canvas, 51 × 38 in. Tate Gallery, London. One of the Impressionists' favorite themes deals with social establishments and bars. Here, Manet shows his virtuosity in handling light, in this case the reflections on the model, the background, and the mirrors. His use of direct lighting eliminates the need for modeling and reveals a complexion lacking in tonal gradations.*

JEAN-FRANÇOIS MILLET

One of the most symbolic figures of Realism in painting. Millet, a man of humble origins, devoted himself to portraying peasant subjects in paintings that were devoid of any Romanticism. A member of the Barbizon School, he produced somber, austere works that were attacked by the critics as being too vulgar. Beginning in 1870, Millet lightened the colors of his palette and set aside figure painting for landscapes that hinted at Impressionism.

Jean-François Millet.

The main street in Barbizon, where Millet lived until his death.

Influences

• Was clearly influenced by photography in his handling of light and figures.
• Always dealt, in a dignified manner, with common, everyday themes. Influenced the work of Seurat.
• Van Gogh became interested in his treatment of themes and pictorial elements.
• Pissarro studied his play of light on objects.

Technical Characteristics

• Displays a genius for drawing, eliminating superfluous elements.
• Renders a realistic portrayal of light.
• Uses backlighting and extreme luminosity.
• Creates brightness using brushstrokes of pure color.
• Sharply models light and shadows.
• Intimates shapes through synthesis of color tones.
• Seeks realism in themes, conveying a certain melancholy in images.
• Takes great care in constructing a composition, aiming for perfect balance between background and figures.
• Landscapes have a far-off perspective, creating a great sense of depth.

Themes

• His first works depict mythological themes and anecdotal scenes.
• Paints portraits as a young man.
• After painting *The Sifter* (Musée d'Orsay, Paris), he devotes himself to depicting rural scenes.
• His rural landscapes often convey a sense of melancholy and sentimentality.
• Figures are treated with the utmost care. Female figures lack qualities of beauty or femininity.
• His landscapes lack the crude Realism prevalent during his time.

LIFE OF THE ARTIST

1814—Born in Gruchy, near Cherbourg (Normandy).
1835—Works with the portrait painter Mouchel.
1837—Studies at Delaroche's studio in Paris.
1845—Meets Troyon and signs a contract with the dealer Durand-Ruel.
1849—Settles in Barbizon with his friend Charles Braque; meets Rousseau, with whom he develops a close friendship.
1854—Thanks to his painter friends and the dealer Sensier, he sells a large number of paintings.
1866—Produces watercolors depicting the Barbizon landscape.
1867—Is deeply affected by the death of his good friend Théodore Rousseau.
1868—Receives the Legion of Honor award from the Brussel's Society of Fine Arts.
1873—His paintings bring higher prices, but his health deteriorates.
1875—Dies in Barbizon and is buried next to his friend Rousseau.

J.F. Millet

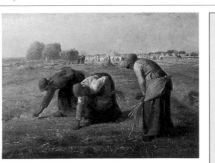

The Reapers *(1856–1857), oil on canvas, 46.5 × 33 in. The Louvre, Paris. Millet's realism dignified the most humble rural tasks, something never before seen in painting. However, the theme does not preclude a carefully structured classical composition and a sense of drama in the interplay of light.*

The Sower (1850–1851), oil, 32.5 × 40 in. Museum of Fine Arts, Boston.

Winter with Crows (1866), oil, 29 × 23.6 in. Kunsthistorishes Museum, Vienna.

Two Diggers (1851–1856), pastel, 37 × 16 in. Museum of Fine Arts, Boston.

The Potato Harvest (1855), oil, 26 × 21 in. Walters Art Gallery, Baltimore.

Wood Collectors (1855), oil on canvas, 18 × 15 in. Norton Gallery of Art, West Palm Beach (Florida).

The Siesta (1866), pastel and black crayon, 16.5 × 11.4 in. Museum of Fine Arts, Boston.

The Raker (1855–1860), oil, 13.5 × 15.6 in. Metropolitan Museum of Art, New York.

The Washerwomen (1855), oil, 20.5 × 16.5 in. Museum of Fine Arts, Boston.

Peasant Woman Baking Bread (1855), oil on canvas, 18 × 21.6 in. Statemuseum Kröller-Müller, Otterlo.

The Angelus *(1857–1859), oil on canvas, 26 × 22 in. The Louvre, Paris. This symbolic work elevates the farmers' prayer to a state of almost mystical meditation. The light of dusk illuminates the figures shown against the light and the hazy countryside in the distance. This work has been reproduced many times during the nineteenth and twentieth centuries and has given Millet a distorted, somewhat puritanical, image. This is incorrect, since the painting deals with more of a social than religious theme.*

I can see clearly the grassy fields and the sun that caresses them; the endless fields, the giant clouds, the steaming earth, and the horses that work the stone-filled soil. And, in this scenery, the wandering, tired man sighs, waiting for the moment when he can catch his breath. The drama is seen in all of its crudeness. This is not fantasy—it is the cry of the earth.

The Potato Planters *(1861–1862), oil, 40 × 32.5 in. Museum of Fine Arts, Boston. Millet deals continuously with the theme of toiling in the fields, showing tired but dignified people who are poor but never wretched. The fusion of the man with the land he works links the tired figure closely to the landscape. The effects of light are rendered almost photographically, accentuating contrasts and brightness.*

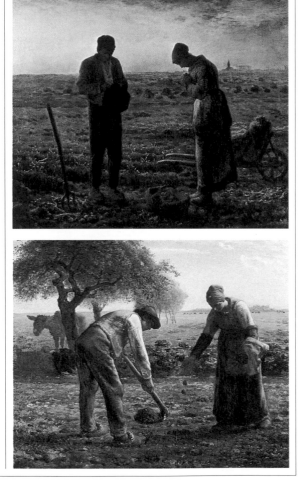

CLAUDE-OSCAR MONET (I)

Claude-Oscar Monet is considered the quintessential Impressionist. His painting titled *Impression: Sunrise* (1872) gave its name to the movement. Monet's idealism was instrumental in bringing the movement to the fore and in shaping the group, that, though consisting of a diverse collection of artists, found in Monet the cornerstone upon which to build and develop different pictorial theories. Monet cultivated Impressionist ideas throughout his career. A highly prolific painter, his work influenced not only the artists of his own time, but those of succeeding generations as well.

Claude-Oscar Monet.

Influences

• Manet's use of color in representing light influenced Monet, who went on to introduce a range of pure chromatic colors in his paintings.

• In their social gatherings, Impressionist painters discussed their ideas on the technical purism of handling light.

• Boudin introduced Monet to open-air painting.

• From Realists such as Courbet, Monet acquired a different point of view on painting.

• The inspiration for Monet's landscape paintings and his desire to capture the fleeting moment in nature came from the Barbizon School, Bazille, and the Fontainbleau group.

• The dominant influence in Monet's synthesis of compositional design, lively brushstrokes, and expressiveness

Claude Monet

came from Turner.

• After the deaths of Alice, his son, and Degas, Monet was encouraged by Clemenceau to continue painting his waterscapes.

• In the last decade of the nineteenth century, Monet's work was influenced by Art Nouveau. Outlines become elongated and more sinuous.

• Monet's dedication to Impressionist theories encouraged the rest of the group to paint outdoors.

• Advances made by Monet in the study of light and color helped Seurat in his development of Pointillism and its scientific treatment of color.

• Monet's influence is decisive in painters such as Sorolla, Arpa, and Mir.

Monet working in July 1915.

Water-lily pond at his Giverny home.

LIFE OF THE ARTIST

1840—Born in Paris.
1855—Sells his first sketches and caricatures.
1857—Eugène Boudin converts him to painting in the open air.
1858—Exhibits his first work in Rouen.
1859—Studies at the Académie Suisse where he meets Pissarro, participates in social gatherings with a circle of Realist painters.
1860—In Le Havre, paints in the open air with Boudin and the Romantic painter Jongkind.
1862—Exhibits at the Galerie Martinet.
1864—Meets Courbet; paints with Bazille at Honfleur.
1867—Period of financial and health crises.
1870—Marries Camille with whom he moves to London after the outbreak of the Franco-Prussian War. Meets the dealer Durand-Ruel.
1874—Nadar organizes an exhibition with works of Monet, Cézanne, Degas, Pissarro, Renoir, and Sisley.
1877—Moves to Vétheuil totally bankrupt.
1883—After Manet's death, organizes a public petition to have Manet's *Olympia* exhibited in the Louvre.
1886—Attends the first Impressionist lunch at the Café Riche, with Pissarro, Renoir, Huysmans, and Mallarmé. Rejects the Legion of Honor Award.
1887—Builds a water-lily pond at his home at Giverny, which inspires a series of paintings.
1899—Loses vision in one eye and is forced to stop painting outdoors.
1918—Builds a special studio boat for painting water lilies.
1919—Eyesight deteriorates, undergoes a cataract operation and regains his vision for a time.
1925—Paints completely blind outdoors.
1926—Dies in Giverny, Upper Normandy, from a tumor.

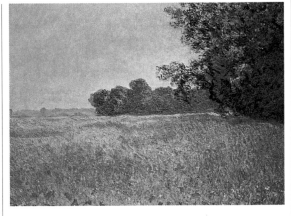

Wheat Field *(1890), oil on canvas, 35 × 27.5 in. Odgen Phipps Collection, New York. The capture of fugitive light, as can be seen in this painting, is one of the characteristics of open air landscapes.*

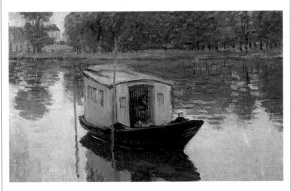

Monet's Boat Study *(1874) (fragment), oil on canvas. Musée d'Orsay, Paris.*

Gare Saint-Lazare *(1877), oil on canvas. McLaren Collection, London. The railroad station is a theme common to many Impressionist painters. Monet painted a series of important works based on this theme.*

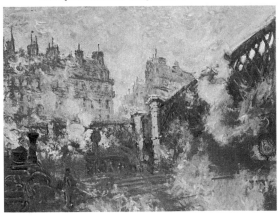

CLAUDE-OSCAR MONET (II)

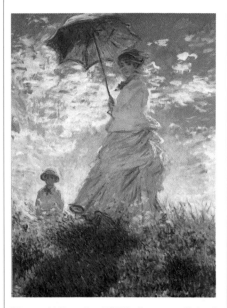

Woman with Parasol and Child, *oil on canvas. National Gallery, London. The framing of the landscape and the figures provide a new perspective to the theme, using the foreground figures to define reference depth in the composition.*

Luncheon on the Grass (1865–1866), oil on canvas, 164.5 × 59 in. Musée d'Orsay, Paris.

Garden in Bloom (1866), oil on canvas, 25.5 × 21 in. Musée d'Orsay, Paris.

Lady in the Garden (1866–1867), oil on canvas, 31.5 × 39 in. Hermitage Museum, Staint Petersburg.

Women in the Garden (1866–1867), oil on canvas, 61 × 81 in. Musée d'Orsay, Paris.

The Saint Adresse Beach (1867), oil on canvas, 40 × 28 in. Musée d'Orsay, Paris.

Boulevard des Capucines (1873), oil on canvas, 31.5 × 23.5 in. Museum of Figurative Arts, Moscow.

Gare Saint-Lazare (1877), oil on canvas, 41 × 30 in. Musée d'Orsay, Paris.

Field of Poppies (1878), oil on canvas, 41 × 30 in. Musée d'Orsay, Paris.

Rouen Cathedral, Morning Sun (1893), oil on canvas, 29 × 42 in. Musée d'Orsay, Paris.

The Parliament in London (1904), oil on canvas, 32 × 36 in. Musée d'Orsay, Paris.

The Lily Pond (1899), oil on canvas, 36 × 36.5 in. Musée d'Orsay, Paris.

The Giverny Garden (1917), oil on canvas, 40 × 32.5 in. Grenoble Museum.

Technical Characteristics

• Use of pure colors.
• Precise, clearly defined brushstrokes.
• Dense brushstrokes alternated with areas of intense oil paint applications.
• Quick staining of the painting before applying dense brushstrokes.
• Alternating techniques: lumps of color paint and smudges applied directly to the canvas.
• Precision in outlining main shapes in the painting.
• Hazy outlines of distant objects.
• Blending of colors on both the palette and the canvas.
• Avoidance of mannerisms in the painting's finish.
• Tonal gradations in the canvas as a way of conveying the quality of the surroundings.
• Rendering of light shining on objects through contrasts: the

Woman with Parasol Turned toward the Left *(1886), oil on canvas, 51.5 × 31.5 in. Musée d'Orsay, Paris. Light is the main element of this painting; the perfectly balanced composition distributes and compensates for the heavy chromatic treatment in the picture by placing the subject on the left. This painting illustrates the direct use of color and the rendering of points of light with short accurate brushstrokes characteristic of Impressionism.*

darker its adjoining tone, the lighter a light tone becomes.

Themes

• Though he produces interior scenes with figures, Monet almost always chooses to paint landscapes.
• Examines, through the treatment of light, the transparency of water and atmosphere.
• In his landscapes, focuses on the effects of light shining on the different objects in the painting.
• Landscapes include garden scenes, sea and waterscapes, and rural and urban views, all of which are rendered under different atmospheric conditions: fog, rain, extreme luminosity (sunrise or sunset).
• As with all Impressionist painters, searches for the unusual subject in his urban landscape paintings: stations, trains, harbor wharves, etc.
• Light is always the focal point in Monet's treatment of figures. Prominent here is the artist's synthetic handling of the anatomical forms, rendered with a sense of haste and immediacy.

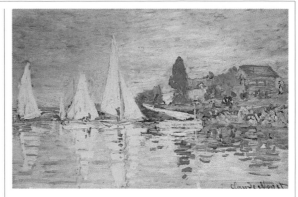

Regatta in Argenteuil *(1872?), oil on canvas, 29.5 × 19 in. Musée d'Orsay, Paris. The light is synthesized though short and precise dabs of paint that expose a moment and instant in space and time. The landscape is powerful in its synthetic representation, whereby more importance is given to reflections and to areas of greatest brilliance than to the recreation of defined shapes.*

Impression: Sunrise *(1872), oil on canvas, 25 × 19 in. Marmottan Museum, Paris. This painting gave its name to the Impressionist group; its title was used as a subject of ridicule by the critic Louis Leroy. The importance of the painting lies in its abstract conception of the landscape that, however, is represented in an entirely figurative way. The thick atmosphere at sunrise allows the viewer, thanks to the use of simple patches of color, to perceive all visible details of the harbor.*

Venice swims in this atmosphere…it is Impressionism in stone. These waterscapes and these reflections have become an obsession…, but I spend delicious moments almost forgetting that I am as old as I am.

Water Lilies, *oil on canvas, 36 × 29 in. Galería Nazionale d'Arte Moderna, Rome. The light contrasts clearly provide a great liveliness in the chromatic rendering of each of the shapes. In this work, Monet does not forget the Impressionist synthetic treatment of objects; he uses broad brushstrokes for the application of large areas of colors. In 1887, Monet built a water-lily pond at his home in Giverny so that he could render from real life a series of water-lily paintings.*

BERTHE MORISOT

One of the most representative figures of Impressionism, Morisot was a link between Manet and the rest of the group. Her marriage to Eugène, Manet's brother, connected Manet to the Impressionists who, against his wishes, made him their ideological leader. An energetic painter, Morisot knew how to foster the ideas that gave birth to the avant-garde artistic movements.

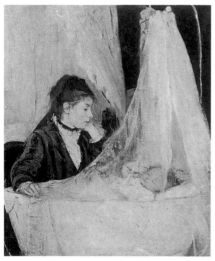

The Cradle (1873), oil on canvas, 18 × 22 in. The Louvre, Paris. Degas had an enormous influence on Morisot. Here one sees nuances of the master both in the technical formulation and intimate nature of the painting.

LIFE OF THE ARTIST

1841—Born in Bourges to a wealthy family, grand-daughter of Fragonard.

1855—Her family moves to Paris. Morisot is attracted to painting from a very young age; her parents hire an art teacher for her.

1859—After working with the painter Guichard, meets Fantin-Latour.

1860—Meets Courbet, who helps her.

1862—Studies at Corot's work-shop.

1864—Participates in official salons until becoming a member of the Impressionist group.

1868—Meets Manet and be-comes his model and ap-prentice.

1874—Participates in the first Impressionist exhibition held in Nadar's studio; marries Eugène Manet.

1880—Begins painting works that are more in line with academic tastes.

1894—Has a highly successful exhibition.

1895—Dies in Paris, leaving behind a large number of works.

Influences

• Encouraged Manet to main-tain close ties with the Impres-sionist group.
• Influenced Manet to elimi-nate black from his palette and to paint outdoors.
• Renoir was the dominant in-fluence in Morisot's work dur-ing the 1880s.
• Degas' work inspired Mori-sot's painting of interior scenes.
• Bonnard and Vuillard later developed the interior themes painted by Morisot.

Berthe Morisot.

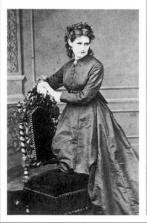

Berthe Morisot (signature)

Technical Characteristics

• Morisot is a master of the academic sketch, though she later denied its influence.
• Shows a great capacity for synthesis of color and form.
• A free, energetic, and ner-vous brushstroke characterizes her work.
• Exhibits a colorist's ap-proach in painting.
• Rejects formal modeling in favor of direct application of color to define form.
• Alternates sketching and patches of color.
• Avoids finish in her paint-ings.
• Her interior scenes are full of life, both thematically and technically.

A Town (1873), pastel, 18.5 × 28 in. Private collection.

On the Grass (1874), pastel, 29 × 36 in. Musée du Petit Palais, Paris.

Portrait of Marie Hubbard (1874), oil on canvas. 20 × 32 in. The Ordrupgaad Collection, Copenhagen.

Eugène Manet on the Island of Wight (1875), oil on canvas, 15 × 18 in. Private collection.

Figure of a Woman at the Theater (1875), oil on canvas, 12 × 22.5 in. Private collection.

In the Dining Room (1880), oil on canvas, 36 × 29 in. Private collection.

Themes

• Predominant in her work are landscapes and intimate interior scenes.

• Important among Morisot's works are her seascapes that show a high level of technique and are always rendered in the Impressionist style.

The Lake in the Bois de Bologne (1879), oil on canvas, 29.5 × 18 in. The National Gallery, London. Free, rapid brushstrokes are the main technical characteristic of this painting. The impastos are executed by applying pure color with precise details to the nearest planes. The framing is highly original and influenced by photography.

> One should live a painting and paint life as if it were the most natural thing to do.

Garden Chair (1855), oil on canvas, 24 × 30 in. Audrey Jones Beck Collection. What stands out in this painting is the almost Expressionist manner of the painting's finish. The forms are barely outlined and the effects of light with the forms are executed with pure, nearly unmixed colors. Morisot's work often vacillates between a loose and spontaneous finish and a more careful finish within a pictorial style approaching that of Renoir or Degas. In this case, the finish is a peripheral element, with pictorial spontaneity acquiring special importance in the work.

On the Balcony (1871), oil on canvas, 19.5 × 23.5 in. Private collection. Berthe Morisot's landscape scenes often depict figures as spectators of the scene. She uses a free style with application of large masses of flat color alternated with patches that convey the most delicate details. Large flat brushstrokes outline forms and volumes without the need for modeling.

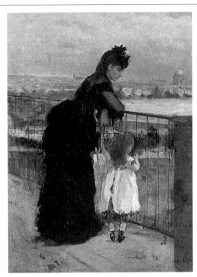

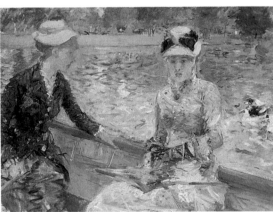

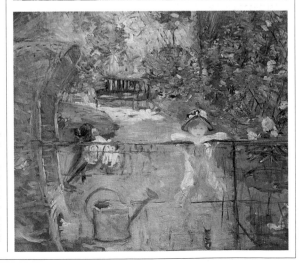

CAMILLE PISSARRO (I)

The only painter who participated in all eight of the Impressionist exhibitions, Pissarro was the artist most beloved and respected by the Impressionist group and was considered its central figure. Cézanne defined himself as "a student of Pissarro." Pissarro was extremely prolific both as a painter and as a graphic artist.

Camille Pissarro.

Self-Portrait, *pen drawing.*

Influences

• Early influences came from Corot, whom Pissarro met at the Exposition Universelle in Paris; from Corot, he acquired an understanding of the lyrical nature of landscapes.
• Ingres' work contributed to his academic formation, for which he shows little interest.

• The Barbizon School had a decisive influence on his artistic understanding of open-air painting.
• Was inspired by the aesthetic freedom and expressive force of the works of Turner and Constable.

Woman in a Garden, Spring Sunshine in the Meadow of Eragny, *oil on canvas, Musée d'Orsay, Paris. This painting shows a precise technical style and a real-life rendition of color. Unlike Seurat, Pissarro emphasizes theme over technique.*

• Cézanne influenced his figure paintings and portraits.
• Adopted the short, small brushstrokes of Signac and Seurat, which eventually led him to a period of Pointillism.
• Pissarro, in turn, had a significant influence on the whole Impressionist group.
• A true Impressionist, he studied color and the effects of light; eventually became interested in Seurat's Divisionist techniques, but abandoned Pointillism after Seurat died.
• A nonconformist, Pissarro experimented with all of the painting techniques that emerged from the group.

Technical Characteristics

• Uses dense brushstrokes.
• Creates planes through small brushstrokes and impastos.
• Uses broken and pure colors.
• Defines shapes without emphasizing contours.
• Replaces tonal gradations with light dots of pure colors.
• Creates atmospheric effects by separating different planes through directional brushstrokes.
• Renders the effect of light vibrations using small, compact brushstrokes, alternating light and dark tones within a single plane.
• Seeks equilibrium in his compositions by shaping masses and the intensity of tones.

Themes

• Though primarily a landscape artist, Pissarro also pro-

LIFE OF THE ARTIST

1830—Born in the Antilles, on the Danish island of St. Thomas, the son of a Jewish father and a Creole mother.

1844—Attends high school in Paris.

1852—Quarrels with his father about his artistic vocation and travels to Caracas with the Danish painter Fritz Melbye.

1855—Travels to Paris where he admires Corot's works and befriends him; studies Fine Arts and the works of the Barbizon artists.

1856—Attends social gatherings and visits painting studios.The Paris Salon accepts one of his landscapes.

1859—Meets and becomes a good friend of Monet.

1860—Begins a close friendship with Cézanne.

1863—Participates in the activities of the newly established Salon des Refusés.

1864—Attends social gatherings at the Café Guerbois.

1868–1870—Devotes himself to open-air painting.

1870—When the Franco-Prussian war breaks out, Pissarro moves to London where he studies the works of Turner and the English landscape painters. In London, his house is burglarized and almost 1,500 of his canvases are taken.

1872—Settles at Pointoise.

1883—Durand-Ruel organizes his first one-man show.

1884—Sells his paintings below market value to support his family; suffers a serious eye disease.

1885–1891—Practices Pointillism until Seurat's death.

1892—Durand-Ruel organizes his second one-man show.

1892—Failing eyesight forces him to stop painting outdoors; paints scenes of Paris from a window.

1903—Dies in Paris.

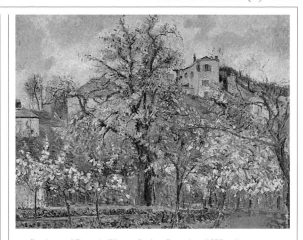

Garden and Trees in Bloom, Spring, Pontoise *(1877), oil on canvas, Musée d'Orsay, Paris. Pissarro likes to paint landscapes and in them makes numerous technical contributions to the theme through his analysis of the effects of light. He uses small, textured brushstrokes of pure colors to create areas of great luminosity and blends other colors on the palette, particularly to paint the scene's secondary planes of the scene.*

duced figure paintings and portraits.

• The stylistic development of his early landscapes clearly show a constant drive and willingness to experiment with all Impressionist techniques.

• Pissarro's figure paintings depict intimate moments and social customs of the day, with the woman always the central focus of the painting.

• His market scenes break with traditional painting.

• Goes through several different technical stages in which technique is always subject to theme, and the rendering of light more important than forms.

• One of Pissarro's important traits is his constant search for

The Road at Louveciennes (1870), oil on canvas, 21.5 × 18 in. Musée d'Orsay, Paris.

Winter Landscape in Louveciennes (1872), oil on canvas, 29 × 23.5 in. Musée d'Orsay, Paris.

Launderer in Pointoise (1872), oil on canvas, 18 × 22 in. Musée d'Orsay, Paris.

Self-Portrait (1873), oil on canvas, 21.5 × 18 in. Musée d'Orsay, Paris.

Harvest in Montfoucault (1876), oil on canvas, 25.5 × 36.5 in. Musée d'Orsay, Paris.

Orchard and Trees in Bloom, Pontoise. Spring (1877), oil on canvas, 32 × 26 in. Musée d'Orsay, Paris.

Red Roofs (1877), oil on canvas, 25.5 × 21.5 in. Musée d'Orsay, Paris.

Road through the Field (1879), oil on canvas, 25.5 × 21 in. Musée d'Orsay, Paris.

Landscape at Chaponval (1880), oil on canvas, 25.5 × 21 in. Musée d'Orsay, Paris.

Young Peasant Girl (1882), oil on canvas, 21 × 25 in. Tate Gallery, London.

Farmer Digging (1882), oil on canvas, 25.5 × 21 in. Private collection, Paris.

View from My Window, Eragny (1894), oil on canvas, 36 × 29 in. Ashmoleam Museum, Oxford.

CAMILLE PISSARRO (II)

Boulevard des Capucines, *photograph of 1872. In the last days of his life, Pissarro painted the boulevards of Paris from his window. Boulevards were a favorite theme of the Impressionists not only as urban landscapes but also because the topic represented a change that opposed the aesthetic and modern painting principles of the Academy. Street life in Paris at the turn of the century was appealing to painters, particularly for its thematic novelty.*

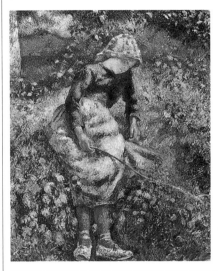

Child with Branch *(1881), oil on canvas, 25.5 × 32 in. Musée d'Orsay, Paris. The figure is depicted without social overtones. The theme, although an outdoor scene, is far from realistic in its treatment. The brushstrokes are small and dense and the colors blended. Contours are ill-defined and the treatment of the effect of light is emphasized. In addition to being an excellent landscape artist, Pissarro shows a talent for portraying figures. In painting them, he experiments with techniques that range from modeling forms to renditions that stress the effects of light and color. He always seeks to harmoniously fuse figures with the landscape, both in terms of masses and of chromatic variations of surrounding spaces. Despite the realistic rendition of forms in the painting, the work's technical treatment varies substantially and is totally innovative. It is up to the viewer to compare what is real with what is not.*

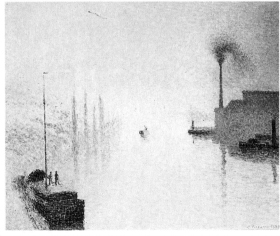

Lacroix Island, Rouen. Effects of Fog *(1888), oil on canvas, 21.5 × 18 in. Private collection, Philadelphia. This work dates from Pissarro's Pointillist period. Its composition is characterized by a delicate lack of details, with only minimal elements conveying the subject of the scene. Pissarro is more interested in depicting the brightness of light shining through the haze than in depicting the scene itself.*

The Geese Caretakers *(1893),*
oil on canvas. Private collection.
In this landscape with two figures,
Pissarro reveals his special interest
for painting scenes that, unlike
Romantic motifs, show different
outlooks of people in Nature.
Impressionism in all of its splendor
is summed up in this work. Among
its most important characteristics
are the study of light in painting,
brushstrokes that stain with small
touches of pure color, the total
absence of valuation, and the lack
of definition in contours.

the expression of color effects
through brushwork techniques
that conform to Divisionist the-
ory. This, together with Seurat's
work, leads to the development
of Pointillism. Pissarro's brush-
work, however, is never overly
technical.

• Alternates the treatment of
space through perspective and
in the manner of Oriental
prints.

• Uses photographic tech-
niques to frame themes.

• Attempts to capture the first
impression of the effects of
light by focusing on the overall
luminosity of the painting as a
whole, not that of its individual
sections.

Paint what is essential to the character of things without being
concerned about process. Don't follow rules and principles when
you paint. Paint what you see and feel. Paint a lot, with enthusiasm
and confidence, striving to capture your first impression. Don't be
intimidated by nature. Be decisive, even though you risk being
fooled and making errors. Your only teacher should be Nature; we
must always consult with her on all things.

Boulevard of the Italians, Paris
(detail) (1897), oil on canvas,
29 × 36 in. Musée d'Orsay, Paris.
The use of innovative themes and
photographic cropping were
two of the most significant issues
in the development of the
Impressionist movement. Pissarro
is one of the greatest masters of
Impressionism and here, far from
the period in which he embraced
Seurat's Pointillism, we see his
ability for synthesis through a
series of concise brushstrokes.

THE ARTISTS

ODILON REDON

He was one of the most original artists of his time. Although Redon was in contact with other Impressionists and exhibited with them, he never became part of the group. Moreover, his role in the new avant-garde movements served to strengthen the new aesthetic theories inherited from Impressionism. An example of this is Redon's strong influence on the Nabis, a group that adopted Gauguin's plastic (three-dimensional) theories. Together with Gustave Moureau he began the Symbolist movement, hinted at by Gauguin in his Symbolist synthesism, and distanced himself from any academic pressure or Impressionist influences.

Odilon Redon.

Influences

• Was influenced by Brasdin in his study of Rembrandt as well as in the analysis of chiaroscuro.
• The botanist Clavaud introduced him to the fantastic literature of Poe, Baudelaire, and Shakespeare, a decisive element in the development of his extravagant imagination.
• Clavaud prompted his interest in the microscopic world and in painting.
• Paintings from Goya's black period influenced the artist's dreamlike quality.
• The Pont-Aven School, started by Gauguin and Bernard in 1888, reinforced Redon's Symbolist ideas.
• Redon's work was decisive in Surrealism, a movement that revolved primarily around the whole world of dreams and fantasy.

Technical Characteristics

• Uses charcoal as his principal means of expression for the first twenty years of his career.
• Masters engraving and lithography techniques.
• Is equally at ease with any pictorial process, preferring oils and pastel.
• Alternates between shading, the superimposition of color and line.
• Blends tones, mixing directly on the canvas.
• Develops a tendency toward polychromy throughout his artistic career, until achieving a painting full of color, always far removed from the chromaticism of naturalism.
• Uses colors rich in contrasts, blending complementary colors.

The Yellow Blanket, (1895) pastel on pasteboard, 14 × 19 in. Private collection.
Ari Redon as a Child (1897), pastel on pasteboard, 12 × 18 in. Private collection.
Boat with Woman (1897), pastel on pasteboard, 20.5 × 26 in. Private collection.
Chariot of the Sun (1905), oil on canvas, 64 × 35 in. Musée du Petit Palais, Paris.
The Red Poppy (1906), oil on canvas, 7.5 × 10.5 in. The Louvre, Paris.
The Chariot of Apollo (1907–1910), oil on canvas, 31.5 × 39 in. Musée des Beaux-Arts, Bordeaux.
The Blue Blanket (Ophelia) (1912), oil on canvas, 22.5 × 20.5 in. Private collection.

LIFE OF THE ARTIST

1840—Born in Bordeaux to a French father and Creole mother.
1855—Studies engraving with Bresdin.
1862—Leaves architectural studies and enters the École des Beaux Arts in Paris.
1864—Founds Symbolism with Moureau.
1870—Learns lithography with Fantin-Latour. Participates in the Franco-Prussian war. Befriends Corot.
1879—Produces his first collection of lithographs.
1880—Marries Camille Faite.
1882—Does a series of lithographs dedicated to Edgar Allan Poe.
1884—Meets the Symbolist poet Mallarmé.
1885—Publishes *Homage to Goya*.
1886—Exhibits at the Salon des Indépendants, founded with Seurat and Signac. Exhibits at the seventh Impressionist exhibition. Publishes a series of lithographs for Flaubert's work *The Temptations of Saint Anthony*.
1899—His work becomes imbued with spirituality.
1899—Exhibits at a large show organized at the Durand-Ruel gallery.
1915—Finishes his journal, which he began in 1867 with the title *À soi-même*.
1916—Dies in Paris.

I put the logic of what is seen at the service of what is unseen.

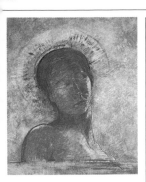

The Closed Eyes *(1890)*, *oil on board, 16 × 20 in. Private collection. In this work we note the pose of the figure, drawn in entirely classic fashion and enveloped in a mystical aura that provides a strong contrast with the light. The atmosphere of the painting as a whole emits golden beams so that it appears as a spiritual vision full of peace and harmony.*

Still Life *(1901), oil on canvas, 18.5 × 11 in. Private collection. This work stands out for its realism inherited from Fantin-Latour and Corot. The totally realist treatment of light in this picture results in an excellently produced still life, where the relationship between colors has been studied in depth.*

ODILON REDON

Themes

• Develops through his painting the world of the unseen, mixing philosophy and science, the macrocosm and the microcosm.

• Shows great interest in the microscopic world, incorporating it into his work along with realistic elements.

• Handles mythological themes as symbols of poetic inspiration, rather than heroic iconography.

Portrait of Gauguin *(1903), oil on canvas, 17 × 26 in. The Louvre, Paris. In one of his most forceful and interesting portraits, Redon here idealizes Gauguin's face, with a profile that is perfectly drawn and adorned with a halo of flowers. This portrait alludes to Gauguin's own work, reproducing his style and even his pure, flat colors, far from any Realist reference.*

Buddha *(1905), oil on pasteboard, 29 × 35.5 cm. The Louvre, Paris. This work was done during a period when the artist was drawn by the theme of wisdom. It has a three-dimensional and chromatic richness, where possibly real colors, such as those in the sky and natural elements, alternate with unreal colors, lifting the composition to nirvana or the pure state of being.*

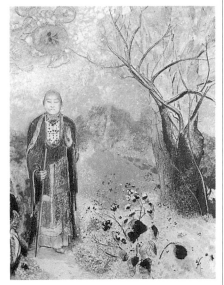

PIERRE-AUGUSTE RENOIR (I)

Renoir's work is unlike that of any other painter in the Impressionist group, as he prefers to represent figures rather than pure landscapes. The subtlety of color and the voluptuousness of shapes make his work unmistakable. He became one of the most outstanding members of the Impressionist group. Despite the misfortunes he suffered early in his career, he managed to become very successful as a portrait artist. He became the most popular and most loved of the group, since his subjects reflected his particular feeling for children and for happy and carefree scenes.

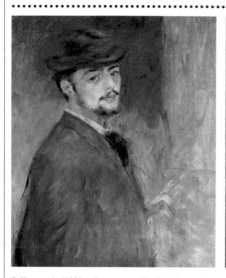

Self-portrait *(1886), oil on canvas, Musée d'Orsay, Paris. In all his works, Renoir shows a particular sense of form and color, displaying great sensitivity to them.*

Gabrielle with Jewels (1910), oil on canvas, 25.8 × 32 in. Private collection, Geneva. Exuberance in Renoir's work is a constant, in terms of both subject matter and technique. The always joyful chromaticism of his work is complemented by his treatment of paint, soft brushstrokes, and undefined outlines of shapes. In contrast, the areas with the most light are direct and strengthen the composition as a whole.

The English Pear Tree *(1855), (fragment), oil on canvas. Private collection. The brushstrokes of pure color are fused directly on the canvas, alternating soft layers of color that are superimposed one on top of the other and that allow layers of color underneath to show through in certain areas.*

Influences

• Copied onto fans the works of Boucher and Fragonard (whom he admired all his life).
• His copying of old masters at the Louvre would influence his work all his life.
• Delacroix's influence can be glimpsed in his works of 1870.
• Laporte invited him to attend Gleyre's studio, where he began his career as a painter.

LIFE OF THE ARTIST

1841—Born in Limoges to a working class family.

1845—His family moves to Paris; his sketches begin to be noticed.

1849–1858—Paints porcelain in the Leug brothers' studio and decorates fabrics and fans.

1849—Takes a night course at the École de Dessin et Arts Décoratifs.

1859—Begins working at Gilbert's studio.

1860—Meets Bazille, Monet, and Sisley.

1862–1864—Attends the École des Beaux-Arts.

1865—Spends time with Monet in the forests of Fontainebleau.

1866—His work rejected by the Paris Salon.

1867—Attends the gatherings at the Café Guerbois.

1869—Moves to his parents' home.

1869—Moves with Monet to the island of Croissy.

1870—Bazille takes him into his studio.

1871—Goes with Monet to meetings with Caillebotte.

1874—Participates in the first Impressionist exhibition.

1875—With a collection of paintings, participates in an auction at the Hotel Druout, which turns out to be a total failure.

1881—Travels through Italy.

1882—Questions the Impressionist techniques and renews his interest in the old masters.

1886—Following the exhibition held in New York, demand for his work explodes.

1892—Durand-Ruel organizes a retrospective of his work.

1893—In Pont-Aven, he opposes the Synthesism of Gauguin.

1894—His second son, Jean, is born.

1910—Because of his rheumatism, he paints with his brushes attached to his hands.

1919—Dies in Cannes.

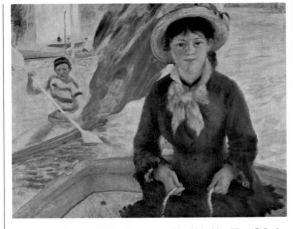

Woman in Boat *(1877), oil on canvas, 36 × 29 in. Mrs. Albert D. Lasker Collection, New York. The figure is always the main character in Renoir's work. While his companions in the group promoted landscape painting, Renoir based his paintings on the theme of the human figure, specifically women, considering himself to be a great observer of them.*

• Bazille and the Barbizon painters encouraged him to paint outdoors.

• Courbet influenced his early work as a painter of realist works.

• Monet's influence was decisive in Renoir's first phase, where we see great similarities in their works.

• The work of Françoise Giradon inspired his *The Large Bathers.*

• Was affected by Velázquez's art and his understanding of shading through color.

• The Impressionist painters' theory of the division of color led him to develop his own interpretation of color.

• Was disappointed by Turner's works, but Lorrain had a profound influence on him.

Technical Characteristics

• Superimposition of thin, transparent layers.

• Gradations of tones are produced within the masses of color with directional brushstrokes that shape the form, without interfering in the chiaroscuro.

Mademoiselle Sicot (1865), oil on canvas, 35 × 45.6 in. National Gallery of Art, Washington.

Portrait of Bazille (1867), oil on canvas, 29 × 42 in. Musée d'Orsay, Paris.

Woman Reading (1875), oil on canvas, 18 × 15 in. Musée d'Orsay, Paris.

The Swing (1876), oil on canvas, 36 × 29 in. Musée d'Orsay, Paris.

Road through High Grass (1876–1878), oil on canvas, 23.6 × 29 in. Musée d'Orsay, Paris.

Dark Young Girl (1879), pastel. The Louvre, Cabinet des Dessins, Paris.

The Railroad Bridge at Chatou (1880), oil on canvas, 25.5 × 21 in. Musée d'Orsay, Paris.

Harvesters' Lunch (1890), oil on canvas, 29 × 37 in. Musée d'Orsay, Paris.

Young Spanish Woman with Guitar, oil on canvas, 22 × 25.6 in. National Gallery of Art, Washington.

PIERRE-AUGUSTE RENOIR (II)

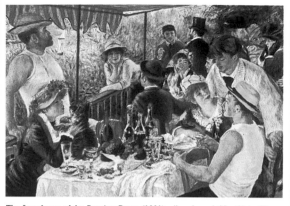

The Luncheon of the Boating Party *(1881), oil on board, 68 × 51 in. The Philips Collection, Washington. The subjects of idle and happy living are constants in the work of Renoir.*

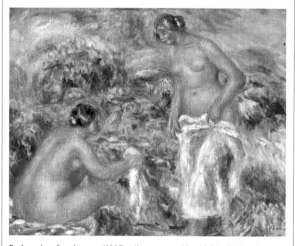

Bathers in a Landscape *(1915), oil on canvas, 20 × 15.7 in. National Museum, Stockholm. Renoir painted this work four years before his death. Note how alive it is despite his having to paint with his brushes attached to his hands.*

• The outlines of shapes are not sharply drawn.
• There is a blurring of dark shades contrasting with bright shades.
• Background and form merge in fading tones.
• After 1883 his work distances itself from the spontaneity of Impressionism and his interest in form increases.
• The modeling of shapes is achieved as in sculpture by stressing light rather than shadows.
• Chromaticism seeks reality in terms of the model's relationship to the light rather than in terms of the model itself.

Themes

• Renoir was primarily a figure painter, though he did paint some landscapes and still lifes.
• The scenes depicted by Renoir characteristically show the joy of life during happy and relaxed moments.
• Renoir painted women and was continuously inspired by them to create portraits or domestic, pastoral, and rural scenes.
• His rural scenes always show joyful and idle themes, where nature is represented as calm and friendly.
• His landscapes are always verdant and alive with extraordinary color.

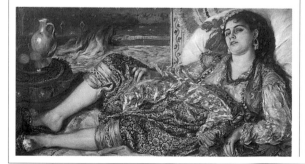

Woman from Algiers *(1870) (fragment), oil on canvas, 37 × 29 in. National Gallery of Art, Washington. This painting shows clear influences from Delacroix, whom Renoir deeply admired. The soft, almost flat modeling of the skin and the strong shading over the couch shows direct, almost aggressive lighting, far from chiaroscuro and close to Courbet's Realism.*

1905 Retrospective of the Impressionists in London, organized by Durand-Ruel. In the center of the photo is Renoir's painting Luncheon of the Boating Party, *reproduced on the preceding page. Duran-Ruel was a great moral and financial support to the Impressionists, especially when their works were not well received by critics or the public. The dealer almost ended in financial ruin defending the painters that he backed. As the exhibitions organized by Durand-Ruel became more frequent, the public and the critics came to accept the work of the Impressionists, creating a great demand for their works among collectors.*

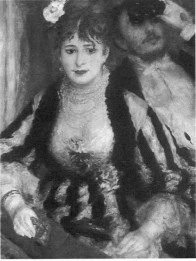

The Box at the Opera *(1874), oil on canvas, 25 × 31.5 in. Courtauld Institute Galleries, London. The play of contrasts is primary in this work. Bright, almost white shades become pearly incarnations alongside darker colors. The technique is supported by subject matter; while the woman is looking at the viewer, her companion wanders absentmindedly among the other theatergoers.*

For me a painting must be a pleasing, pretty, and happy thing. Life already has too many things that irritate us for us to invent still more.

Young Girls at the Piano *(1892), oil on canvas, 35.5 × 45.6 in. Musée d'Orsay, Paris. In this painting, Renoir depicts the intimacy of a domestic scene. Unlike other works by the painter, the shapes of the figures are perfectly defined and he uses a soft modeling of the forms. Detailed work alternates with the diffuse areas that are characteristic of the rest of his work.*

Le Moulin de la Galette *(1876), oil on canvas, 69 × 51.5 in. Musée d'Orsay, Paris. This work shows one of Renoir's favorite themes— celebrations and boisterous places; in this he is like his Impressionist colleagues. The treatment in this painting is subordinated to the light that filters through the leaves. Tonal values do not vary, but rather are offered like new colors, giving way to a gentle effect of movement.*

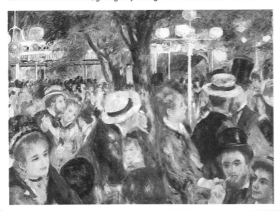

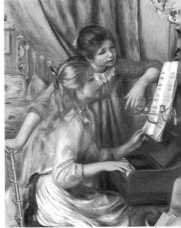

THE ARTISTS

GEORGES-PIERRE SEURAT (I)

Seurat created Neo-Impressionism together with Signac. He used and developed the Pointillist technique, developing theories of color, which great masters such as Pissarro and van Gogh came to adopt at some point in their careers. His movement had a large number of followers, but none of them were able to match the perfect mastery of its creator. Although he only lived to 32, he left a pictorial and technical legacy that greatly influenced the work of later generations of artists.

Influences

• Delacroix influenced his palette since, according to Seurat, he developed a similar one.
• The calm and tranquil vision of Puvis de Chavannes, a student of Delacroix, had a strong influence. By studying Puvis de Chavannes's work, Seurat sought to synthesize Symbolism and Impressionism.
• The Impressionists influenced Seurat's way of modeling of the natural world and his search for unusual subjects that were far removed from those of academic painting.

Georges-Pierre Seurat.

Detail of the Pointillist technique used for Sunday Afternoon on the Island of La Grande Jatte *(1891). The colors are not worked on the palette, but are applied as small dots of pure color directly on the canvas. The resulting colors remain in the eye of the viewer.*

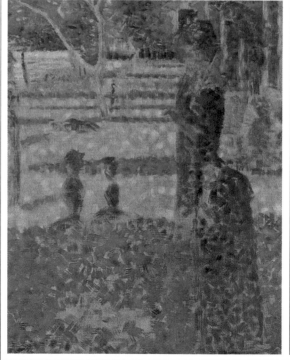

Study of Sunday Afternoon on the Island of Grande Jatte *(1891) (detail), oil on canvas, Musée d'Orsay, Paris. Seurat painstakingly analyzes this work in all of its possible formal and technical aspects. His ceaseless experimentation with color recalls the Impressionists' effort to convey first impressions in their open-air paintings. Even though Seurat's technique created misgivings among the Impressionists regarding his pictorial contribution to the movement, purists like Pissarro used Divisionist theory in several of their paintings.*

LIFE OF THE ARTIST

1859—Born in Paris to a family of modest means but with properties that allow him to lead a comfortable life.

1875—Enters the municipal school of drawing.

1878—Thanks to the influence of Edmond Aman-Jean, Seurat enters the École des Beaux-Arts in Paris. He is a mediocre student but strives to copy the great masters at the Louvre.

1879—Rents his first studio with Aman-Jean and Laurent.

1881—After visiting the fourth Impressionist exhibition, he leaves the École des Beaux-Arts. He studies the electromagnetic theories of light and the way the retina perceives optic rays.

1882—Studies in depth the optical fusion of colors.

1882—His work begins to take on Impressionist influences.

1884—With Signac and Redon, he founds the Salon des Artistes Indépendants.

1886—Meets the mathematician Charles Henry. The rest of the Impressionist group is put on the defensive. Durand-Ruel presents an exhibition of the work of Seurat and Signac in New York.

1888—With his painting *The Parade*, he becomes the precursor of the aesthetic theory of Charles Henry.

1889—The polemic surrounding his work leads him to personal isolation.

1891—Dies suddenly in Paris.

• Odilon Redon guided him toward Symbolist painting.

• Signac helped strengthen his studies on light and color.

• Unlike Pissarro and Signac, Seurat's studies extended beyond color to drawing and compositional harmony.

• The mathematician Charles Henry assisted him in his scientific-artistic investigations.

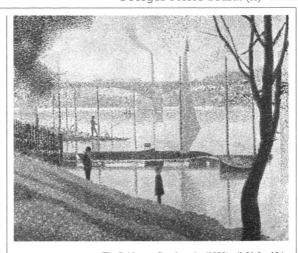

The Bridge at Courbevoie *(1886), oil, 21.6 × 18 in. Courtauld Institute Galleries, London. This work is one of the best examples of Seurat's landscapes. Forms and composition are studied with great precision, seeking perfect equilibrium between the lines that comprise each of the elements.*

• Seurat's Divisionism, in turn, had an influence on Gauguin, who would eventually develop Synthesism, wherein pictorial planes are converted into masses of color separated by sketchy lines.

• Van Gogh quickly adopted Seurat's theories, evolving into an understanding of painting as gestural and symbolic expression.

• Picabia and Matisse followed in Seurat's footsteps, with paintings employing a symbolist understanding of color, rather than a colorist representation of reality.

• Symbolism found in Divisionism an escape for pictorial representation.

Technical Characteristics

• For Seurat there is no difference or contradiction between science and art.

Woods at Pontaubert (1882), oil on canvas, 31 × 25 in. Private collection, London.	*Bathing at Asnières* (1833–1834), oil on canvas, 79 × 118.5 in. National Gallery, London.
White House in Ville d'Avre (1876), oil on canvas, 13 × 18 in. Walker Art Gallery, Liverpool.	*Horses on the Seine* (1883), oil on wood, 6 × 10 in. Courtauld Institute Galleries, London.
House among the Trees (1833), oil on wood, 6 × 9 in. Art Gallery and Museum, Glasgow.	*House on the Outskirts* (1883), oil on canvas, 12.5 × 16 in. Private collection, Troyes.
Quarry Worker with Cart in Le Raincy (1876), oil on canvas, 6 × 10 in. Private collection, Washington.	*Panorama of the Grande Jatte* (1884), oil on canvas, 25.5 × 32 in. Private collection, New York.
Men Fishing on the Pier (1859–1891), oil on canvas. Art Institute of Chicago.	*Profile of Seated Model* (1877), oil on wood, 9.5 × 5.7 in. Musée d'Orsay, Paris.

GEORGES-PIERRE SEURAT (II)

• Uses color as if it were a mosaic of tiny tiles.

• The blending of colors on the palette tends toward black; in contrast, pure colors applied in small smudges on the canvas are mixed on the retina.

• Pure colors used together provide a simultaneous contrast of complementary colors.

• Light changes color in the areas it illuminates; the colors of these objects overlap and yield complementary colors.

• He begins technically by superimposing broad brushstrokes on top of one another using a palette influenced by Delacroix that includes pure colors and earthy colors.

• In his attempt to capture real color, he manages to create a dense but luminous atmosphere, more like the ideal, poetic image than the real image.

• Toward the end of his life, Seurat includes sinuous lines, anticipating Art Nouveau.

• He introduces borders and figures using Pointillist technique, an attempt to demonstrate that any subject can be developed with this technique.

• His preliminary works develop a denser Pointillism, where he seeks to express colors directly, a subject that interests Gauguin.

Themes

• Landscapes, figures, portraits, and the world of entertainment are Seurat's most frequent subjects. However, the importance of his work does not lie in the subject matter selected, which he uses as an excuse for research.

• The landscape is his primary thematic reference. Pointillism creates a luminous and dense atmosphere in his landscapes.

• Within his landscapes, he develops studies of composition using figures, always with very careful structuring of forms.

• He seeks to capture from the landscape the nuances of light and shadow.

• The use of figures with his technique gives it a certain solemn and rigid character.

• The world of entertainment and the circus, as well as itinerant orchestras, give Seurat a

Sunday Afternoon on the Island of La Grande Jatte *(1884–1886), oil on canvas, 121 × 81 in. Art Institute of Chicago. Considered one of the most important works of Neo-Impressionism, this painting represents the birth of Pointillism, a technique that blends colors optically on the retina of the viewer, by placing small dabs of complementary colors that optically give rise to other colors. To create this large work, Seurat did preparatory tests, studying the physical effects of light on different objects. It is obvious that composition is one of Seurat's primary interests; each of the figures is placed so that the painting remains perfectly balanced.*

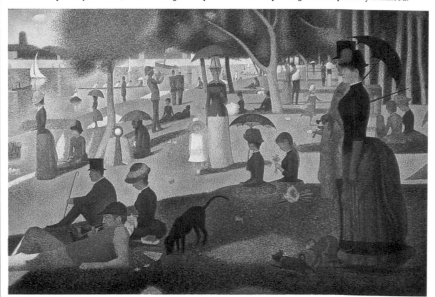

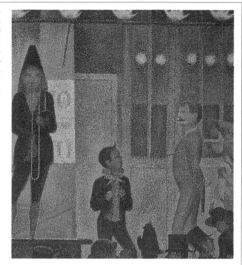

The Parade *(detail) (1888), oil on canvas, 59 × 39 in. Metropolitan Museum of Art, New York. In this work, Seurat applies the different theoretical principles developed by Charles Henry. In addition to the Pointillist technique, he gives the lines a psychological meaning in their interpretation by the viewer; descending lines and cold colors produce agitation and loneliness, while warm colors, ascending lines and sharp angles produce joy and euphoria.*

platform on which to carry out his chromatic and optical experiments.
• Psychological themes are first used in Seurat's work based on the use of different moods.

> The use of technical elements such as color, line, and tone should be subject to rigorous and scientific calculations. But the impressions that the work of art as a whole (line, tone, color) create in the sensibilities of man cannot be subjected to calculation.

The Circus *(1891), oil on canvas. Musée d'Orsay, Paris. One of the paintings done with fewer preparatory studies. It was exhibited unfinished in the Salon des Indépendants in 1891. In this work, we can see a compendium of all of Seurat's theories of color and form: colors obtained from the optical blend of other, pure colors; curved forms; and the use of simultaneous contrasts. The subject is already classic among the Impressionists—the circus, and the world of entertainment. The circus theme is also a constant in the early avant-garde movements. Seurat refers to it on various occasions, always as an excuse for his pictorial experiments, thus justifying the application of his technique to any of painting's themes. The closeness of the different points of color is reproduced on the viewer's retina as if the colors were created on the palette.*

Young Woman Powdering Herself *(1889–1890), oil on canvas, 31 × 37 in. Courtauld Institute Galleries, London. Seurat was always quite reticent about his personal life, so much so that few knew that he had a wife and son. In this painting, he depicts his wife, Madeleine Knoblock. The people in Seurat's portraits tend to be so refined that their primary significance lies in the play of forms and technical experimentation.*

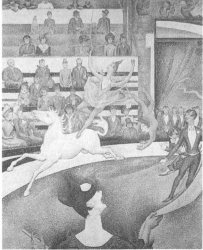

PAUL SIGNAC

One of the closest followers of Seurat, whose Synthesist theories he defended vehemently, although he carried them to such a theoretical extreme that he reached an aesthetic that was more outwardly forceful than it was profound. With Seurat, he was one of the founders of the Salon des Indépendants.

Influences

• Monet's large exhibition in 1880 led him to dedicate his life to painting.
• Both Monet and Guillaumin encouraged him to paint.
• Seurat's work had a great effect on the artist, so much so that he veered in his Impressionist course toward Divisionism.
• From the time he embraced Pointillism, his studio became the meeting place for Neo-Impressionist artists.
• Signac used the Neo-Impressionists' theories in his work.
• He compiled the Neo-Impressionist theories in a book

Paul Signac.

that appeared in 1889 with the title *From Eugène Delacroix to Neo-Impressionism.*

Technical Characteristics

• He begins painting with a purely Impressionist technique, interested in the effect that light produces on objects.
• After seeing the work of Seurat, he uses Pointillist technique.

LIFE OF THE ARTIST

1863—Born in Paris.
1882—Completes his studies at the École des Arts Décoratifs in Paris; works with Seurat at Asnières.
1884—Influenced by the Impressionists, he helps to found the Salon des Indépendants, exhibiting there at the age of 21.
1899—Writes *From Eugène Delacroix to Neo-Impressionism.* Until his death, presides over the Salon des Indépendants.
1908—President of the Société des Artistes Indépendants, a position he holds until shortly before his death.
1935—Dies in Paris.

• Tries to resolve the contradiction between Impressionist style and Seurat's chromatic laws.

Windmills in Montmartre (1884), oil on wood, 10.6 × 13.8 in. Musée Carnavalet, Paris.
Faubourg de Paris: La route de Gennevillers (1883), oil on wood, 35 × 44 in. E.G. Bürle, Zurich.
Apprétense et garnissense, rue du care (1885), oil on canvas, 35 × 44 in. E.G. Bürle, Zurich.
Breakfast in the Dining Room (1886), oil on canvas, 45 × 35 in. Rijksmuseum Kröller-Müller, Otterlo.
The Railway Junction at Bois-Colombes (1886), oil on canvas, 18.5 × 13 in. Leeds City Art Gallery, Leeds.
Boulevard Clichy, a Snow Scene (1886), oil on canvas, 25.8 × 18.3 in. The Minneapolis Institute of Arts, Minneapolis.

La berge, Petit-Andely *(1886), oil on wood, 32 × 25.5 in. Private collection, Paris. Unlike Seurat, Signac uses a palette with less white, a purist issue that is reflected in his more aggressive chromaticism, thus limiting the atmosphere achieved by Seurat.*

The Port of Saint-Tropez *(1894), oil on canvas. Musée de l'Annonciade, Saint-Tropez. Set up in Saint-Tropez, Signac used the wharf of the port as the reference for his work, rigorously applying Pointillist and movement theory in each of his works. The slight evolution he made in terms of Pointillism consisted of alternating various types of brushstrokes within a single painting, always mindful of developing the theory. In this work, the studied composition of each of the planes alternates with the triangular shapes of the sails, seeking subtle gradations in tone. The Pointillist treatment of the sky and the boats differs from that used for the water, where the brushstrokes are longer. The precision of the brushstroke was so meticulous that the small dots are nearly identical.*

Women at the Well *(1892), oil on canvas, 51 × 76 in. Musée d'Orsay, Paris. This work was shown at the Salon des Indépendants in 1893 with the title* Provençal Women at the Well, *decorated for a shadow panel. After Seurat's death, Signac settled in Saint-Tropez, where he became obsessed by the harmonic ranges of Puvis de Chavannes. This work was done very precisely, with numerous preparatory sketches as well as pencil drawings meticulously studying both color and the composition of the general lines of the painting. In Signac's work, figures have a decidedly solemn character, given the Pointillist technique; people appear to be immobile, as if frozen in a dense atmosphere with its own luminosity that envelops all objects in the work.*

• Uses Pointillism to approximate reality, using only pure colors.
• Bases his creations on the optical laws of Chevreul.
• Starting in 1990 he paints large canvases with great chromatic harmony.

Themes

• All types of themes using the Pointillist technique, but rendered so scientifically that he seems to freeze the images in his concern for chromatic study.
• His landscapes are particularly interesting, with great meticulousness and analysis of color.

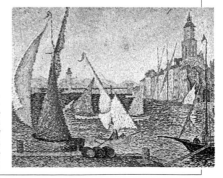

The Red Buoy *(1895), oil on canvas, 25.5 × 32 in. Musée d'Orsay, Paris. This painting shows the port of Saint-Tropez, where Signac arrived in 1892. The range of colors used for the houses underlines an emphasis on color. Unlike the pure Pointillism of earlier periods, his small brushstrokes here are much more dynamic, following the technique of Divisionism. The importance of Seurat's theories is decisive in Signac, who follows them obsessively.*

ALFRED SISLEY

The first British member of the group of Impressionist painters. His melancholy and introverted nature led him to produce highly lyrical landscapes. He influenced the group's landscape works, without ignoring the scientific detail of the play of light on objects.

Bazille, Portrait of Sisley, *oil on canvas. Musée d'Orsay, Paris.*

Influences

• Influenced by Corot's sense of construction.
• Greatly influenced by the Barbizon painters and the masters of eighteenth-century Dutch landscape painting.
• His contact with Cézanne, Manet, or Renoir influenced him to create works within the Impressionist school.
• Signac and Seurat influenced his Pointillist work.
• The expressive freedom of the British watercolorists influ-

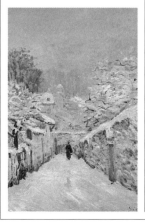

First Snow at Louveciennes (1870), oil on wood, 29 × 21 in. Museum of Fine Arts, Boston.
The Canal of Saint Martin in Paris (1870), oil on canvas, 29 × 21.5 in. Oskar Reinhart, Winterthur.
The Bridge at Villeneuve-La-Garenne (1888–1890), oil on canvas, 25.8 × 19.5 in. Musée d'Orsay, Paris.
The Canal of Saint Martin (1872), oil on canvas, 18.3 × 15 in. Musée d'Orsay, Paris.
The Island of Saint-Denis (1878), oil on canvas, 25.5 × 20 in. Musée d'Orsay, Paris.
View of the Canal of Saint Martin (1870), oil on canvas, 25.5 × 19.6 in. Musée d'Orsay, Paris.
Landscape at Louveciennes (1873), oil on canvas, 32 × 26 in. Musée d'Orsay, Paris.
Villeneuve-La-Garenne sur Seine (1872), oil on canvas, 31.7 × 23 in. The Hermitage Museum, Saint Petersburg.

enced his manner of capturing atmosphere.

Technical Characteristics

• One of Sisley's main objectives is to reorganize space.
• Staggers the different planes of the painting.
• Interested in the illusion of three dimensions and depth in his landscapes.

Snow at Louveciennes *(1878) (fragment), 19.6 × 6.3 in. The Louvre, Paris. The atmosphere achieved is very dense with an abundance of white.*

• Seeks formal equilibrium between the different elements in the work.
• Paints a large number of landscapes, most of which depict the Ile-de-France; although during his lifetime his work is not as important as that of the other Impressionists, he has a special place among the Impressionists.
• Rejects academic conventions in pursuit of Impressionist purism.
• Uses a fluid and direct brushstroke.
• Does not define the contours of shapes.
• Seeks impression through light; in this way objects are represented and he is one of the purest Impressionists.

LIFE OF THE ARTIST

1839—Born in Paris into a well-to-do British family.
1856—Is sent to England to begin studies in business.
1862—Enters the École des Beaux-Arts, where he meets Monet, Renoir, and Bazille.
1863—Exhibits at the Salon des Refusés.
1871—Goes to England during the Franco-Prussian war.
1871–1874—Paints in Hampton Court and the suburbs of London.
1874—Exhibits at the first Impressionist exhibition.
1876—Participates in the second Impressionist exhibition.
1877—Participates in the third Impressionist exhibition.
1882—Settles at Moret-sur-Loing, Ile-de-France.
1899—Dies alone without obtaining French citizenship.

Highway of the Machine in Louveciennes *(1873), oil on canvas, 29 × 21 in. Musée d'Orsay, Paris. One year before the first Impressionist exhibition, Sisley painted this landscape in which the road vanishes into the horizon. It is a perfectly balanced painting, alternating an off-center perspective recession with a heavier foreground as a visual counterweight. The different perspective planes are superimposed, creating a perfect three-dimensional effect.*

Fog, Voisins *(1874), oil on canvas, 25.6 × 19.6 in. Musée d'Orsay, Paris. With some influences from the work of Corot, Sisley depicts a spring morning with a strong effect of fog. All the forms are blurred, with a grayish tendency produced with the use of white. The brushstrokes in the background are broad and rapid, becoming denser the nearer the plane is to the viewer.*

What painters do I like? To mention only contemporary artists, Delacroix, Corot, Millet, Rousseau, Courbet, our teachers—all who have loved Nature and have felt it strongly.

• His skies are expansive, showing depth and atmosphere; the lines of perspective are strengthened with the different elements in the painting.

Themes

• In Sisley, the principal theme is the landscape, which he uses constantly, demonstrating a strong sense of compositional construction.

The Flood at Port-Marly *(1876), oil on canvas, 32 × 23.6 in. Musée d'Orsay, Paris. This scene was painted by Sisley in at least half a dozen paintings; he was interested in the rising waters and flooding of the Seine. Of the paintings he did of the subject, this is the most famous, because of its resolution of bright colors and reflections on the water, as well as the study of the atmosphere. In this work, we can see the influence of Monet, but with greater interest in construction that leads the painter to a respect for shapes.*

THE ARTISTS

HENRI-MARIE-RAYMOND DE TOULOUSE-LAUTREC (I)

Toulouse-Lautrec is one of the most important heirs to Impressionism. Among the early avant-garde, his work came to be highly valued because of its force and originality. With incomparable fluidity and talent, he developed his own Expressionism, bringing a great legacy to the art of both the nineteenth and twentieth centuries. His work is blessed with critical and ironic realism and develops marginal themes, scenes in cafés, cabarets, and the theater, with the value of drawing always predominating over painting.

Toulouse-Lautrec.

Influences

• Early on, because Bonnat criticized his drawing, he set out to study drawing from nature with great seriousness.

• Strongly influenced by book and magazine illustrators such as Jean-Louis Forain as seen in the sharply drawing-like character of his works.

• His work exudes definitive influences from Degas, both in his themes and in the style of drawing. Degas' influence led to his abandoning the rigidity of the academicians.

• The Japanese print influenced the artist, causing him to appreciate space and leave behind the western perspective.

• Van Gogh's Expressionism influenced the outline of his drawing.

Photography had an enormous impact on the work of Toulouse-Lautrec. Many of the subjects he painted, such as cabaret and interior scenes, were based on photographs.

Self-portrait in ink. This drawing is one of the best aspects of this controversial artist. He presents a fluid line, with character and great knowledge of anatomy.

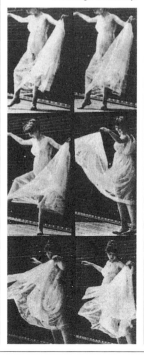

Artilleryman Saddling a Horse (1879), oil on canvas, 14.7 × 22 in. Musée Toulouse-Lautrec, Albi.

Model in Studio: Hélène Vary (1888), oil on pasteboard, 8 × 14 in. Musée Toulouse-Lautrec, Albi.

Mister Warner (1892), oil on paper, 18 × 22.5 in. Musée Toulouse-Lautrec, Albi.

Loïe at the Folies-Bergere (1893), oil on pasteboard, 18 × 25 in. Musée Toulouse-Lautrec, Albi.

Woman at the Window (1893), oil on pasteboard, 18.5 × 22.5 in. Musée Toulouse-Lautrec, Albi.

The Laundress of the House (1894), oil on paper, 18 × 23 in. Musée Toulouse-Lautrec, Albi.

Misia Natanson (1895), charcoal and color on paper, 41.3 × 58 in. Musée Toulouse-Lautrec, Albi.

Woman Passenger in No. 54 (1896), lithographic billboard, 15.6 × 23.2 in. Bibliothèque Nationale, Paris.

The Actress Berthe Bady (1897), oil on pasteboard, 23.6 × 27.6 in. Musée Toulouse-Lautrec, Albi.

Young English Girl on the Star at Le Havre (1899), oil on wood, 13 × 16 in. Musée Toulouse-Lautrec, Albi.

LIFE OF THE ARTIST

1864—Born in Albi; of noble background, he was weak and sickly at birth.

1871–1874—Studies in Paris; returns to Albi and begins to draw.

1878—As a result of two falls from a horse, he is left deformed at the age of 14.

1880—During his convalescence, he devotes his time to studying and drawing, although he is limited in terms of models.

1881—Starts at Leon Bonnat's studio and continues to study drawing.

1882—Starts at Fernan Cormon's studio but feels dissatisfied with the level of teaching and criticism.

1883—Moves to the Rue Fontaine studio.

1886—Meets van Gogh.

1887—Opens a studio on the Rue Calaincourt in Paris, but spends most of his time at the Moulin Rouge.

1888—His emotional relationships are with dancers and prostitutes, leaving him disillusioned and depressed.

1890—In defense of van Gogh's work, he challenges H. Groux to a duel.

1891–1892—Spends time with his cousin Gabriel Tapie, a physician.

1893—Joyant organizes an exhibition of lithographs for him.

1894—Alternates his work as a graphic artist with his dedication to painting, exhibiting in several European galleries.

1894—Meets the owner of the *Revue Blanche* and becomes interested in the entertainment world.

1895—At the Vuillard exhibit, he disguises himself as a waiter.

1896—He is commissioned to do several billboards.

1898—Is confined in a clinic to recover from alcoholism.

1900—Seriously ill, his creative work takes off.

1901—Dies at the castle of Malrome, Gironde.

The Bed *(1892), paint on pasteboard and wood, 27.8 × 21.3 in. Large masses alternate with elements of detail, as in Japanese painting. Graphics and line predominate over color.*

• Gauguin, Émile Bernard, and the Nabis led him to a pure treatment of color and to an appreciation of line as the principal value.

• He adopted lithography as his own and was the first to hold an exhibition of this technique.

Technical Characteristics

• With great plastic talents, he handles all pictorial techniques: oil, watercolors, *gouache,* and pastels.

• Seeks a perfect drawing of the model.

• Expressive exaggeration of physical traits, even to the point of distortion.

• Graphic quality predominates over pictorial quality.

• Use of pure color.

• Direct and edgy strokes; continuous line defines shapes.

• Masters the new lithographic technique, which allows for effects similar to those achieved in paintings: synthesized smudges, uniform surfaces of flat color.

• In terms of composition, he develops a photographic vision of the model.

• Divides the space in the painting with large masses among which the recognizable elements of the figure stand out.

• Superimposes planes, expressing the spatial arrangement of the different elements of the model.

• Ignores perspective putting the size of the principal elements first and diminishing the size of distant elements.

Themes

• Toulouse-Lautrec was passionate about horses and depicts them frequently.

• Bordello and cabaret scenes are constant in his work; he became famous drawing the billboards for Aristide Bruant's cabaret and the Moulin Rouge.

• He painted the stars of such locales: Jane Avril, *la Goulue,* Yvette Guilbert.

• *La Goulue* opened a fair booth in the Place du Trône and the artist decorated it with painted canvases.

• He painted scenes of medicine, surgery, and hospitals.

• He took inspiration from circus entertainment and from the cycle track.

• Daily life and intimate scenes were important themes in his work.

HENRI-MARIE-RAYMOND DE TOULOUSE-LAUTREC (II)

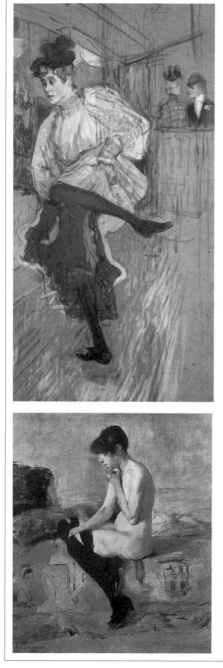

Jane Avril Dancing *(1882), oil on pasteboard, 17.7 × 33.5 in. Musée d'Orsay, Paris. Parisian night life is the principal source of the artist's inspiration. Jane Avril, a dancer at the Moulin Rouge, was one of his favorite lovers and models. Despite his grotesque appearance, Toulouse-Lautrec enjoyed great popularity at the night spots and the favor of many cabaret dancers, with whom he was frequently intimate. In this work, the principal figure takes up most of the painting; its slightly off-center composition makes it possible to impart great depth to the whole, which is reinforced in the shape of the frame. Here the painter manages to give life to the essence of the person. Beyond the physical structure, he knows how to express essential values through a simple and totally uncluttered work, as if dealing with a caricature. He has few rivals as a master in the art of observation; with a rapid and light hand, he expresses traits, movement, and rhythm, poking fun at calligraphy and photographic accuracy.*

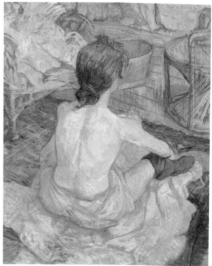

The Toilette *(1896), oil on pasteboard, 21.3 × 26.4 in. Musée d'Orsay, Paris. Degas had a strong influence on Toulouse-Lautrec, both in terms of technique and in how he sees the model. Despite this, he develops his own particular view of anatomy, with a great synthetic sense for form.*

Nude Woman on Couch *(1882), oil on canvas, 21 × 21.6 in. Musée Toulouse-Lautrec, Albi. All of Toulouse-Lautrec's nudes are imbued with strong sensuality. This work belongs to his first period, after he had worked at Bonnat's studio. His interest in the human figure had already been evident in one conscientious study after another, until he mastered proportions and gesture.*

Henri-Marie-Raymond de Toulouse-Lautrec (I)
Henri-Marie-Raymond de Toulouse-Lautrec (II)
Joseph Mallord William Turner

89

Drawing Room at the Rue des Moulins *(1894), pastel on paper, 52 × 43.7 in. Musée Toulouse-Lautrec, Albi. Brothels and the carefree, bohemian nightlife were frequent subjects for the painter, who spent many hours there. Drawing dominates over painting, and conventional perspective is ignored as in Japanese engraving. Facial expressions and poses are very natural, and everything is contained in a luminous chromatic synthesis.*

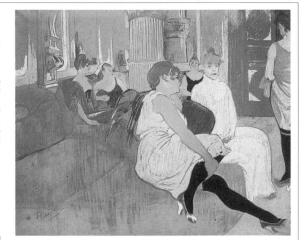

Everywhere ugliness has its beautiful aspect, and it is exciting to discover it precisely where no one ever noticed it.

Chau-U-Kao in Her Dressing Room *(1895), oil on canvas, 18 × 21.6 in. Musée Toulouse-Lautrec, Albi. The daring foreshortening of this pose shows a nearly photographic view because it is so natural. Drawing is dominant in terms of the division of space (a theory taken from Gauguin), the masses of color are broad and pure, underlining the plane of the figure with warm tones against a complementary background. In this work, the artist achieves a perfect synthesis in which he manages to combine the line of the drawing, the personality of the person depicted, her mood of the moment, and the frivolous atmosphere that emanates from her.*

Marcelle Lender Dances the Bolero at Chilpéric *(fragment) (1897), oil on canvas, 59 × 57 in. Whitney Museum, New York. All of Parisian night life was captured by the brush of this artist. The dynamic line and the synthesized impression of the figure give the scene a dynamism that only Toulouse-Lautrec could capture. Here the painter shows an effort to enter the interior life of the character, to achieve an approximation of her character, her traits. Thus, despite the apparent spontaneity, everything is perfectly studied, nothing is gratuitous—the position of the leg, the movement of the dress, the incline of the body, the arm, the twisting of the hips, etc. A series of details that, when combined with the setting, the warmth, and the accompanying cast of characters, support the intended goal.*

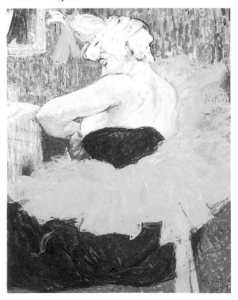

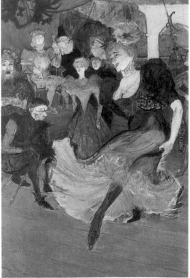

JOSEPH MALLORD WILLIAM TURNER

Turner is without a doubt one of the essential figures in the development of Impressionism and all painting after his time. He developed a very personal style in his study of the effects of the atmosphere and light in Nature. The effects used in his work and his search in composition for something far removed from Classicism gave a new sense to romantic painting. Moreover, in Turner the Impressionists discovered a new frontier of both thematic and technical possibilities.

Self-portrait, *oil on canvas.*
Tate Gallery, London.

Influences

• In his early years, he was inspired by the works of John Robert and Paul Sandey.
• In his early work, he was strongly influenced by the collector Monro.
• From Cozens he took pictorial language, an interest in light and atmospherically charged perspectives.
• He used the techniques of van de Velde, van Ruysdael, and Vernet as the basis for painting his first seascapes.
• Lorrain was his point of departure for pictorial experimentation.
• He learned the technique of using oils by painting historical works.
• In his first visit to the Louvre in 1802 he acquired a great feeling for light, and his compositions become softer.
• His trip to Venice influenced his dreamlike view of the landscape. The relationship be-

LIFE OF THE ARTIST

1775—Born in London to a humble family.
1784—Begins to color engravings and sell drawings in his father's barbershop.
1794—Exhibits for the first time at the Academy School.
1800—Elected member of the Royal Academy, where he would give classes for thirty years.
1802—Travels to Paris and Switzerland.
1814—Does engravings to pay off his debts.
1819—Visits Italy and develops a fundamental phase in his work.
1820—Reproaches himself for the lack of polish in his oils; it is precisely this that makes him the most important painter of his time.
1836—Visits France, Switzerland, and the Aosta Valley.
1842—His landscapes are more and more blurred, becoming unreal worlds.
1846—Lives apart from the world under a fictitious name, doing research on light.
1851—Returns to his home in London, where he dies a few months later.

Fishermen at Sea (1796), oil on canvas, 48 × 36 in. Tate Gallery, London.

The Thames at Walton (1876), oil on wood, 29 × 14.5 in. Tate Gallery, London.

Willows along a Stream (1807), oil on canvas, 45.6 × 33.8 in. Tate Gallery, London.

Rome from the Vatican (1820), oil on canvas, 131 × 69.5 in. Tate Gallery, London.

Piazza di San Marco (1830), watercolor, British Museum, London.

Musical Gathering (1835), oil on canvas, 35.6 × 47.6 in. Tate Gallery, London.

Twilight over a Lake (1845), oil on canvas, 48 × 35.8 in. Tate Gallery, London.

Landscape (1845–1850), oil on canvas, 19 × 13.4 in. The Louvre, Paris.

turnEr

tween the model and its representation would be an influence in symbolism and surrealism.
• The "lack of polish" in his work would influence the Impressionist painters' view of reality.

Technical Characteristics

• Masters all watercolor techniques, seeking the light underlying transparency, alternating successive layers of color over dry and wet surfaces.
• Completely eliminates drawing-like sketches.
• Turner's technique with oils has the mark of a great watercolorist; transparencies, superimpositions, and veiled tones are constants.
• Abundance of experimental techniques (varnishes, medium, tempera), which have caused many of his works to deteriorate over time.

The Burning of Parliament (1835), oil on canvas, 48.5 × 36.5 in. Museum of Art, Cleveland, Ohio. This scene made a great impression on Turner and he developed the subject on many occasions. The figures are barely hinted at and disfigured by the atmosphere. Abstraction in the paintings of Turner is one of the characteristics most followed by the avant-garde painters of the nineteenth and twentieth centuries. By not incorporating clearly figurative references, his work as a whole distanced itself from the figurative references of the painters of his time.

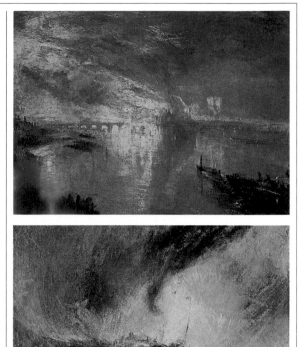

• After his trip to Rome in 1819, his chromaticism becomes pure; he sets aside gray and earthy tones and takes up a palette of orange, yellow, blue, and violet tones.
• Handles the work with spontaneous resolution, fluid brushstrokes.
• Converts brushstrokes into a play of light and color.
• Develops landscape like a flow of light with increasingly more direct and fluid brushstrokes.

Themes

• Works with historical themes in his early period, notably *The Death of Nelson*.
• He is primarily a landscape painter but he understands Nature as an animate subject, that seeks to dominate human beings with its force.
• He creates figures endowed with an atmosphere that envelops and integrates them, sometimes with slightly abstract shapes.
• Handles themes that were unusual for his time, such as trains, fog, or speed.

Snowstorm (1842), oil on canvas, 48 × 36 in. Tate Gallery, London. In the exhibit catalogue for this work, the following comment was made about this painting: "Snowstorm: sailboat approaching port while sending signals and making soundings of the reefs." In these views of Nature, Turner interprets reality through light filtered by the atmosphere, an element that Impressionism will later take to heart.

Rain, Steam, and Speed (1844), oil on canvas, 48 × 35.8 in. Tate Gallery, London. In this initial depiction of a train, the composition is based on a perspective going toward a slightly off-center point of flight. This work's great attraction lies in its magnificent treatment of light based on the superimposition of transparencies that express an almost abstract atmospheric effect.

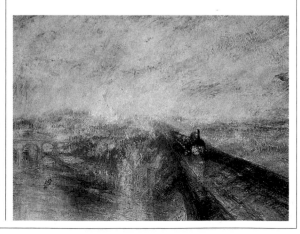

ÉDOUARD VUILLARD

The career of this painter, decorator, and lithographer is closely linked with those of his friends Denis and Bonnard. Within the Postimpressionist tradition, he developed a significant role among the Nabis, heirs to Gauguin's Synthesism. He took many snapshots with a camera, using them later to develop pictorial works with intimate themes.

Self-portrait *(1903), oil on pasteboard, 13.4 × 16 in. Private collection, New York.*

Influences

• Vuillard was mainly influenced by Gauguin's Synthesism; he used large masses of flat color with a clear separation between them.
• The Japanese print influenced the artist's method of composition.
• His intimate themes are reminiscent of Berthe Morisot's treatment of the same themes.
• Was influenced by the Pointillism of Seurat.

Technical Characteristics

• He doesn't take real illumination into account.
• His small brushstrokes create dense but subtle textures and atmospheres.
• He develops a form of divisionism that is close to abstract painting, using pure colors and broad smudges.
• His interiors are imbued with great delicacy and subtlety, with a somewhat antiquated air.

• The portraits of his final period show elements characteristic of the academicians, both in the treatment of light and in the modeling of shapes.

Themes

• Decorates sets for theaters: gardens, landscapes, interior scenes...
• His best works depict intimate scenes.
• He paints a large number of portraits.
• His landscapes are closed and intimate, depicting people resting or relaxing.
• He creates still lifes in which he radically distorts light and shadows.

The Dining Hour (1891), oil on canvas, 36.3 × 28 in. Museum of Modern Art, New York.

Oil Lamp (1891), pencil on paper, 5.4 × 4.3 in. S. Weining Collection, New York.

Theater Scene (1893), oil on pasteboard, 20.5 × 8 in. Landesmuseum, Hannover.

Motherhood (1896), four-color lithograph, 9 × 7.5 in. Bibliothèque Nationale, Paris.

Toulouse-Lautrec at the Natanson's (1898), oil on pasteboard, Musée Toulouse-Lautrec, Albi.

Portrait of Léon-Abel Gaboriaud (1938), oil on canvas, 31 × 36.6 in. Musée Historique, Lyon.

LIFE OF THE ARTIST

1868—Born in Cuiseaux, the son of a retired military man.
1877—His family moves to Paris; he studies with the Marists.
1886—After being rejected for admission to the École des Beaux-Arts, he enters the Académie Julien. After studying fine arts, he joins the Nabis group along with Sérusier, Bonnard, Maurice Denis, and Ranson.
1891–1894—Exhibits with the Nabis at Le Barc de Boutteville in Paris. Contributes to the *Revue Blanche* published by the Natanson brothers.
1892—Does large sets for the Natansons, Claude Anet, and Antoine Bibesco.
1899—Participates in the Exhibition/Homage to Odilon Redon, organized by the dealer Durand-Ruel at his gallery.
1901—Exhibits for the first time at the Salon des Indépendants.
1908—Travels to London with Bonnard.
1909—Exhibits regularly at the Salon des Indépendants.
1912—Exhibits at the Bernheim-Jeune hall and is commissioned to create sets for the Comédie-des-Champs-Elysées.
1914—Called up to serve as a linesman near Paris.
1917—Serves as a painter for the army.
1938—Elected member of the Academy of Fine Arts.
1940—Dies at La Baule after the German invasion.

La Meule *(1907), painting in tempera on canvas. 65 × 92.5 in. Musée des Beaux Arts, Dijon. Vuillard did this work based on the photographic model shown at the left. The photograph was taken in 1905. The influences of Impressionism are obvious in all of Vuillard's works. He presents a loose sketch, defining shapes with brilliant brushstrokes and alternating flat masses of color with luminous lines that trace the texture of the field.*

Photograph taken by Vuillard; served as the model for La Meule.

We perceive Nature through our senses, which give us images of shapes, colors, dreams, etc. A shape, a color, exists only in relationship to another shape or color. Isolated shapes don't exist. We only conceive relationships.

The Lilies *(1890), oil on pasteboard, 11 × 13.8 in. Private collection, New York. Within the Nabis group, Vuillard takes Gauguin's plastic theories to the extreme, developing a completely flat style of painting, with no alteration other than the chromatic changes produced by the contrasts between forms and colors. Since the forms are so extreme, the dividing line becomes unnecessary and he does away with it altogether.*

Woman with Soup Tureen *(1890), oil on wood, 6.7 × 8.3 in. Private collection. This work still shows Seurat's strong influence over later generations of painters, although we see this not in the search for a true analysis of light and color, but rather as a pictorial technique closer to the acid colorism of Gauguin. Forms are not implicit in the smudge, but rather are formed on the retina.*

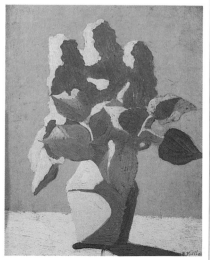

OTHER ARTISTS

Impressionism meant the start of a new era in the history of painting, a seed that took root throughout the world, giving rise to hundreds of pictorial movements and great masters who, influenced by the Paris group, have developed Impressionist lines or lines close to this understanding of reality.

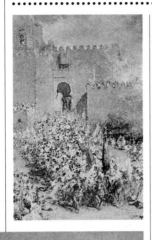

José Arpa (Carmona 1860—Sevilla 1952). In 1883, Arpa travels to Rome where he sees the paintings of the great masters. He travels to Morocco and in 1896 to Mexico and the United States, where he lives for a few years. He shows marked realist influences but his fluid and direct brushstroke as well as his interpretation of Nature give him an important role among the precursors of Impressionism in the United States and in the school of Sevilla.

◀ Outcry, oil on canvas, 19.7 × 30 in. Private collection, Sevilla.

Émile Bernard (Lille 1868—Paris 1941). Considered the inventor of Cloisonism, which Gauguin would later call Synthesism (process using flat painting with a dark contour line). Exchanged letters with Cézanne.

◀ La Moisson au bord de la mer (1892), oil on canvas, 27.5 × 36 in. Musée d'Orsay, Paris.

Johann Barthol Jongkind (Ladorp 1819—La-Côte-Saint-Germain 1891). Dutch painter who settled in Paris in 1846. Considered the most direct precursor of Impressionism. His watercolors painted at La-Côte-Saint-André are done with a fragmented brushstroke, subjecting the image to the impression.

▼ Beach at Saint-Adresse (1863), watercolor, 22.4 × 11.8 in. Musée d'Orsay, Paris.

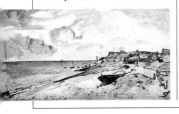

Maurice Denis (Granville 1870—Saint-Germain-en-Laye 1943). Studied at the Académie Julien along with Sérusier, Bonnard, and Vuillard (the Nabis). Developed the group's theoretical position, popularizing the as yet unknown figure of Gauguin.

▼ Homage to Cézanne (1900), oil, 94.5 × 71 in. Musée d'Orsay, Paris.

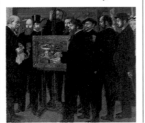

Marià Fortuny (Reus 1838—Rome 1875). Began to study in Rome in 1857 and in Morocco in 1860. A serious student of Rembrandt and Goya, she developed important work as an engraver. She linked up with the French dealer Goupil. Developed an exotic type of painting. Although she would disdain Impressionism, her work sometimes shows characteristics of this movement.

▲ Seminude Man, watercolor. Goya Museum, Castres.

Théo van Rysselberghe (Gante 1862—Sant Clar 1926). With Octave Maus, founded the group of 20 in Brussels. This painter served as the link in artistic relations between Paris and Brussels. Had contacts with the Parisian Neo-Impressionists and succeeded in having their works exhibited in Belgium.

▲ Sailboats and Estuary (1892), oil on canvas. Musée d'Orsay, Paris.

Honoré-Victorin Daumier *(Marseilles 1808—Valmondois 1879). Painter and engraver, one of the great masters of the customs and manners genre and social caricature. Starts with newspapers in 1830, working for various Parisian publications, always defending freedom of expression. His pictorial work, with its great plastic expressiveness, was recognized only after his death.*
▶ The Emigrants *(1850–1855), oil. Musée du Petit Palais, Paris.*

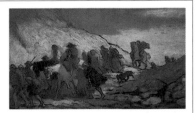

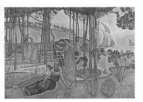

Henry-Edmond Delacroix *(Douai 1856—Var 1910). Known as H.E. Cross. One of the founders of the Salon des Indépendants, together with Seurat and Signac. He took some time to embrace the Divisionist technique of Seurat, never reaching his level of study. His work is more directed to the search for subtler harmonic ranges.*
◀ Evening Air *(1893), oil on canvas, 65 × 45.6 in. Musée d'Orsay, Paris.*

Paul Sérusier *(Paris 1864—Morlaix 1927). One of the founders of the Nabis group, he achieved a symbolist synthesism. His work combines naturalism, synthesism, and mysticism. His presence among the avant-garde became less important after the 1921 publication of his theoretical study* The ABCs of Painting.
▶ The Talisman *(1888), oil on wood, 10.6 × 32 in. Musée d'Orsay, Paris.*

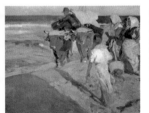

Joaquín Sorolla *(Valencia 1863—Cercedilla 1923). Spanish painter. Influenced by his trips to Paris, he submerged himself in Impressionist illuminism, setting aside historical scenes and painting in the open air. His friendship with A.M. Huntington brought him to international recognition. The Museo Sorolla in Madrid holds an extensive collection of his works, including 300 canvases, 800 sketches, and more than 4,000 drawings.*
◀ Taking Out the Boat *(1916). Private collection.*

Théodore Rousseau *(Paris 1812—Barbizon 1867). French landscape artist, main promoter of the Barbizon School, where, during the late 1840s he decided to follow the influences of Constable and Bonington and pursue a program similar to the one they left behind.*
▶ Vue de la plaine de Montmarte, effet d'orage *(1845), oil, 14 × 9.3 in. The Louvre, Paris.*

James Abbot McNeil Whistler *(Lowell 1834—London 1903). Associated with the artistic avant-garde, he began by imitating the style of Courbet and Manet. He settled in London in 1859, although he continued his association with the Parisian artists. After being rejected at the salons from 1860 until 1865, his art began to strengthen as he cultivated his own particular style. A great portrait artist, he rejected painting in the open air and the color of light.*
◀ Harmony in Blue and Silver: Courbet at Trouville *(1865), oil on canvas, 30 × 19.7 in. Isabella Steward Gardner Museum, Boston.*

Ignacio Zuloaga *(Eibar 1870—Madrid 1945). Spanish painter. In 1890 he traveled to Paris, where he attended the Académie La Palette; his professors include Puvis de Chavannes, Gervaux, and Carrière. He met Degas, Gauguin, and Toulouse-Lautrec. His painting is characterized by great energy, construction of volume influenced by Cézanne, three-dimensional density derived from van Gogh, and predominance of line from Gauguin. Like Degas, he creates his compositions with the central motif set off-center.*
▶ Study in Grays *(1896), oil. Private collection.*

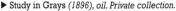

Note: The titles that appear at the top of the
odd-numbered pages correspond to:

The previous chapter
The current chapter
The following chapter